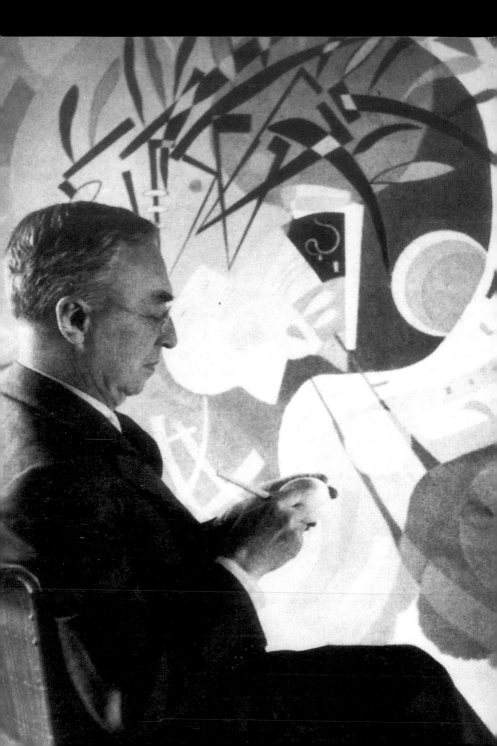

Art Book
Kandinsky

DORLING KINDERSLEY

London • New York • Sydney

www.dk.com

Contents

How to use this book

This series presents both the life and works of each artist within the cultural, social, and political context of their time. To make the books easy to consult, they are divided into three areas which are identifiable by side bands: yellow for the pages devoted to the life and works of the artist, light blue for the historical and cultural background, and pink for the analysis of major works. Each spread focuses on a specific theme, with an introductory text and several annotated illustrations. The index section is also illustrated and gives background information on key figures and the location of the artist's works.

■ Page 2: photograph of Wassily Kandinsky in his studio at Neuilly sur Seine in 1938. Taken by Bernard Lipnitzki, Centre G. Pompidou, Paris.

1866–1899

Professor of law or artist?

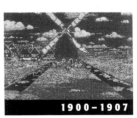

1900–1907

The lure of art

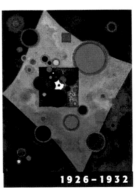

1926–1932

The Bauhaus in Dessau

1933–1944

The Paris years

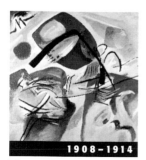

| 1908–1914 | 1915–1921 | 1922–1925 |

The genius period **Return to Moscow** **The Bauhaus in Weimar**

Index & Biography

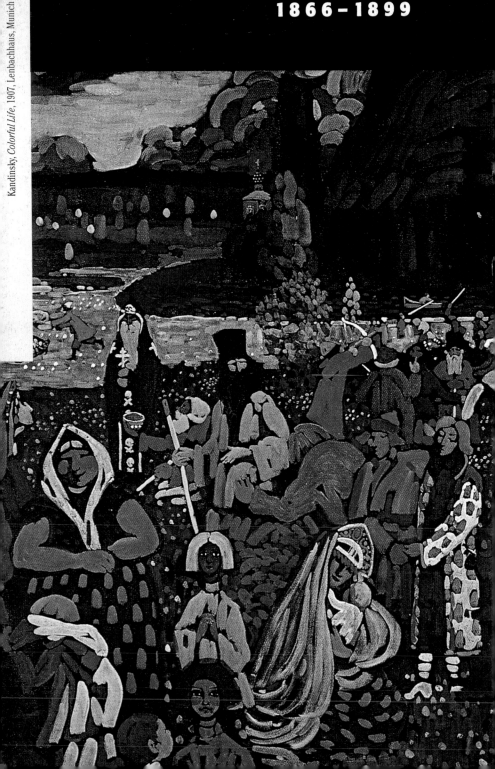

Kandinsky, *Colorful Life*, 1907, Lenbachhaus, Munich

Professor of law or artist?

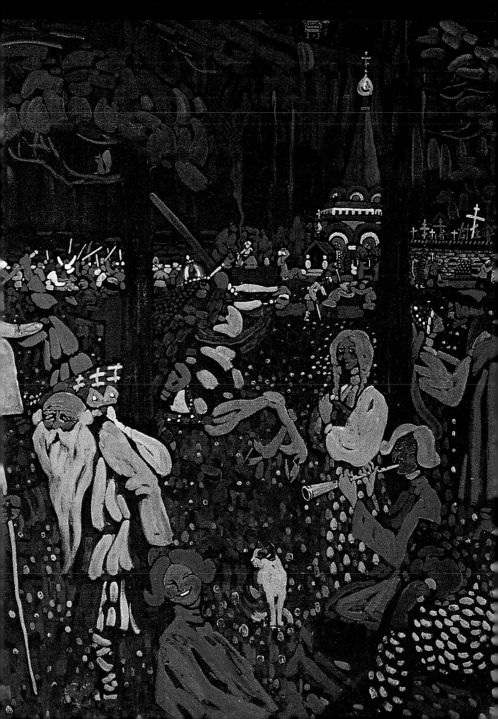

Childhood in Moscow

▲ St Basil's Cathedral, symbol of Kandinsky's beloved "mother Moscow".

On December 4, 1866, Wassily Wassilievich Kandinsky was born in Moscow. He was to become one of the most passionate and influential figures in the world of contemporary art. His father Wassily was a wealthy tea merchant, his family originating from an area bordering Mongolia and Manchuria. His mother Lydia was from a noble Muscovite family, so it was proud Russian blood that flowed in the young Kandinsky's veins. In his early years, he benefited from a range of influences. On his father's side there was considerable interest in art and drawing, with an equally strong interest in music and painting on his mother's side. He was read Russian and German fairytales and taught the piano and the cello. In 1869, his parents took him to Italy, an experience that never left him. Another significant influence was the figure of his maternal aunt, Elisaveta, who took a special interest in the spiritual and cultural development of her nephew. It is clear that Kandinsky was a child of rare quality: he was capable of reproducing from memory paintings he had seen in museums, and was gifted with an extraordinary sensitivity to color. After a move to the Ukrainian seaport Odessa in 1871 and his parents' separation (an event that affected him profoundly), Kandinsky attended high school, where he performed well.

◀ This charming picture, taken in 1874 by Yavorovsky, shows Kandinksy when he was living in Odessa. Centre G. Pompidou, Paris.

◀ Grigory Miasoedov, *The Zemstvo Lunch*, 1872, State Tretyakov Gallery, Moscow. Grigory Miasoedov was part of the Association of Wanderers, who painted images of real life.

▲ Archip Kuindzi, *Ukraine Night*, 1876, State Tretyakov Gallery, Moscow. Another of the Wanderers, Archip Kuindzi was among the first in Russia to be drawn to Symbolism.

▼ Kandinsky, *Odessa – The Harbor*, c.1898, State Tretyakov Gallery, Moscow.

▲ Nikolai Jarosenko, *The Student*, 1881, State Tretyakov Gallery, Moscow. Pictured here is an idealistic modern hero.

▲ *The Barber Trims the Beard of a Scismatist*, 18th century, Saltikov-Scedrin Library, St Petersburg. This popular print is the most famous image of pro-Tsar propaganda of the time: the beard, a "useless bundle", was symbolic of opposition to the Tsar.

Odessa, queen of the Black Sea

Colonized by the ancient Greeks, Odessa, the capital of the Ukraine, was one of the most important commercial centers in the region. It was also a city of architectural merit, home of the famous Potemkin steps, which lead to the harbor.

1866–1899

The discovery of reality

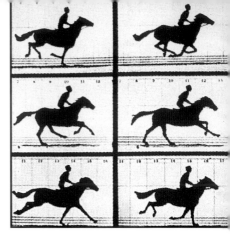

While the young Wassily was growing up and beginning his art education, political events were in turmoil. In Russia in 1861, serfdom was abolished and administrative and judicial reforms began to come into effect. However, in 1881, the Tsar Alexander II was assassinated and his successor Alexander III reverted to absolutist power. Throughout Europe, social balances were generally shifting: the class system was in a state of flux, and there were already signs that the working class would swiftly succeed in obtaining more power. In France, the Impressionists were creating a startling new style of painting; in Italy, there was the Scapigliatura movement and the Realist painting of the Macchiaioli artists; and in Great Britain, thanks to the Arts and Crafts Movement, the role of design was increasingly valued, spreading to the Continent and encouraging appreciation on all social levels. These were the years in which Realist poetry flourished widely, accompanied by a desire to liberate art from the academic stereotypes derived from classical tradition.

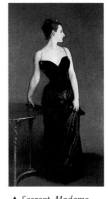

▲ Sargent, *Madame Gathereau*, 1883, Private Collection. Sargent's fashionable society beauty is both seductive and elegant.

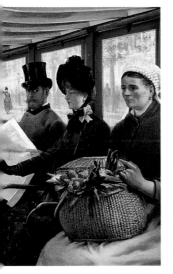

◀ Delondre, *On the Omnibus*, 1880, Musée Carnavalet, Paris. The female condition is illustrated in this painting from the 1880s, in the form of a bourgeois woman and a working-class woman.

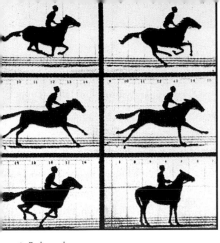

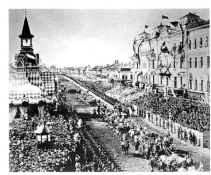

▲ Eadweard Muybridge, *Horse in Motion*, 1878. By the second half of the 19th century, photography had reached a high technical level and research focused on the ambitious aims of the moving picture.

▲ On June 26, 1894, Nicholas II was proclaimed Tsar in a spectacular public ceremony.

◄ In the late 19th century in the southern United States, strolling blues musicians improvising melancholy tunes appeared on the scene. Jazz was beginning to emerge.

At its roots were the work songs of black sailors (there were thousands of African immigrants), minstrel songs, and gospel singing.

▼ Silvestro Lega, *The Betrothed*, 1869, Museo della Scienza e della Tecnica, Milan. Lega was a particularly gifted Macchiaioli painter.

▲ The applied arts reached particularly sophisticated levels of form, as can be seen in this metal teapot by the British designer Christopher Dresser (c.1878, British Museum, London).

11

1866–1899

An earnest student

▲ The German composer Richard Wagner (1813–1883) was one of the musicians who strongly influenced the young Kandinsky, exemplifying those who ceaselessly sought the perfect union between color and sound.

Love for Moscow drew Kandinsky back to the city, and in 1885 he enrolled at the Faculty of Jurisprudence. In his heart, he associated the figure of his mother with his image of the city, the former sweet and lovely, the latter dignified and seductive. He visited numerous churches with his father, from whom he gained a good understanding of the great historic and ethical value of Russian cultural heritage. In Moscow, he spent his student years filled with genuine curiosity for the subject of law: "It absorbed me and helped me to develop abstract thought," he wrote in 1913 in *Reminiscences*, "Roman law…in its extremely elegant construction…criminal law, the history of Russian law and the law of the peasant…and lastly the kindred science of ethnography, through which I promised myself from the beginning that I would get to know the soul of the people".

His results were so good that in 1889 the Imperial Society of Natural Sciences, Anthropology, and Ethnology sent him on an expedition to the remote region of Vologda to study the culture of the Finnish Zyrians. Contact with the colors of their costumes and the decorated interiors of the peasant dwellings had a profound effect on him, teaching him "to live in the picture".

▼ Kandinsky, drawing of the church of the Nativity of the Virgin in Moscow, 1886, Nina Kandinsky Legacy, Centre Pompidou, Paris.

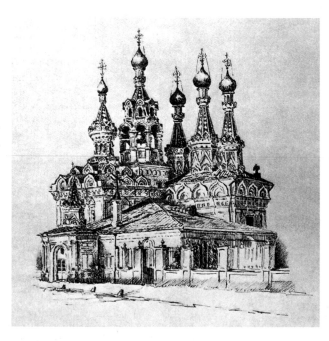

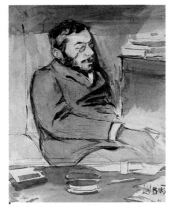

► Léon Bakst, *Portrait of Aleksander Benois*, 1914–1915, S.D. Lanzere Collection. The depiction of the human face changed dramatically once the threshold of the principle of literal representation had been breached. Art now "interpreted" the subject, tracing only the basic outlines.

► Above, far right: the influence of Franz Kafka (1883–1924), the German-speaking Czech writer, on both contemporaries and successive generations, is undeniable. Works like *Metamorphosis* assail the body as well as the spirit. Physiological distortion would also be a subject of interest to the artistic avant-garde.

The "new man" of the 20th century

Echoing the mood of the turn of the 18th century, the late 19th and early 20th centuries saw the slow process of man acquiring an individual conscience, free will, and the capacity for critical reflection – both on himself and the world. Its roots lay in the philosophical principles of

Humanism and the Renaissance. At the same time, this "new man" was fragile, because the attainment of inner satisfaction and certainty involved doubt, loss, and pain. Unresolved problems emerged as reality failed to exhaust the questions of life. Delving into his depths, the new man discovered a contradictory, elusive double that would later be the subject for psychoanalysis.

▼ Photograph by V. Dimo of the young Kandinsky as a student in about 1885, Centre G. Pompidou, Paris. He shared the Russian people's desire for renewal.

Red Square

Red Square is one of the largest squares in the world. It is dominated by the Kremlin, a gigantic complex that has always

been used for political and religious functions. The square, also traditionally an important commercial center, takes its name from the color of many of the buildings.

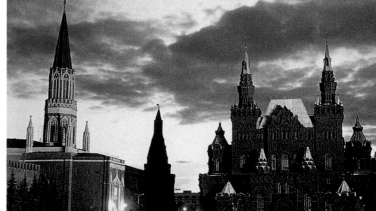

The century ends

At the end of the 19th century, music and theater flourished, both in traditional styles and in the form of avant-garde material from figures such as Claude Debussy, Richard Wagner, Modest Mussorgsky, and Arnold Schoenberg. Many painters and sculptors of this period – for example Auguste Rodin and Franz von Stuck – were to leave equally indelible marks on the evolution of taste and the history of the arts. Architecture also flourished, forming a mirror for industrial and social evolution, with new materials and stylistic innovations that overturned centuries-old practices. Great strides and important discoveries were also made in the different scientific fields, such as medicine, chemistry, and physics. In Milan in 1883, the first Italian electricity power station was built, one of the first in the world. These scientific conquests in themselves prompted art towards another phase of development: Positivism, delving into the constitutional laws of natural phenomena, implicitly urged artists to go beyond the threshold of visible appearances.

▲ Léon Bakst, drawing of Nijinsky in the role of the faun in *Prélude à l'après-midi d'un faune* by Debussy. Bakst and Debussy were among the most innovative artists working at the turn of the century.

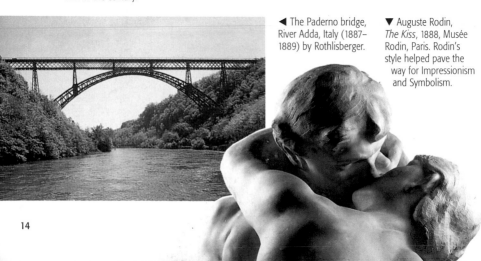

◄ The Paderno bridge, River Adda, Italy (1887–1889) by Rothlisberger.

▼ Auguste Rodin, *The Kiss*, 1888, Musée Rodin, Paris. Rodin's style helped pave the way for Impressionism and Symbolism.

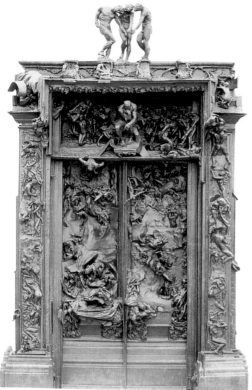

▲ Henri de Toulouse-Lautrec, *The Redhead in the White Jacket*, 1889, Private Collection, France. A new style of woman, very different from classical models, began to make her appearance among pictorial subjects.

▲ Auguste Rodin, *The Doors of Hell*, 1880–1917, Musée Rodin, Paris. Rodin was the sculptor most representative of turn-of-the-century French modernity.

▼ The Statue of Liberty (1886) was the new symbol of the United States.

▼ London's Tower Bridge (1886–1894) by Barry and Jones is a bascule bridge.

▲ Franz von Stuck, *The Sin*, 1893, Neue Pinakothek, Munich. A painter and sculptor of high repute, von Stuck was regarded as the founder of the Munich Secession. His pictorial style was both Post-Impressionist and Symbolist. He was much admired for his rigor of method.

15

1866–1899

A change of direction

▲ Kandinsky, sketch-book drawings of knights, Lenbachhaus. The artist's preciseness and great capacity for observation is evident in these sketches.

▶ Claude Monet, *Haystacks*, 1890–1891, Musée d'Orsay, Paris. Fascinated by Monet's *Haystacks,* Kandinsky commented: "The painting showed itself to me in all its fantasy and in all its enchantment. Deep within me the first doubt arose about the importance of the object as a necessary element in a picture."

Art, the only thing capable of satisfying Kandinsky's "inner necessity", was now calling him. In 1889, he visited Paris and, little by little, his interest in art grew. Three years later, aided by his excellent photographic memory, he passed his state exams in law with such high marks that he was appointed faculty assistant. In the same year, he married his cousin Anya: it was not a love-match, but more a close friendship with a person who was cultivated and intelligent. She was, however, little inclined to take into account the creative side of her partner. In 1895, Kandinsky put his university career on one side and took up a post as art director at the Moscow publishing house Kušverev. The job did not last long. In 1896, three significant events occurred that made him decide to devote his life to art: a visiting Impressionist exhibition (he was stunned by the non-substance of Monet's *Haystacks*); a performance of *Lohengrin* by Wagner at the Bolshoi (he realized how powerfully the composer had attained a synthesis of sound and color, something that he also wanted to achieve); and the discovery of the splitting of the atom, which brought about the collapse of all his certainty about the absolute and unequivocal solidity of what is real.

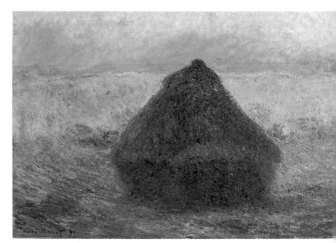

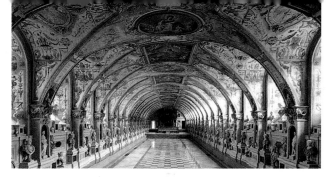

◄ Interior of the Munich Residenz, seat of the dukes of the region.

► Rembrandt, *The Parable of the Rich Man*, 1627, Staatliche Museen, Berlin. The perfect harmony of pictorial tones in the Dutch painter's work revealed to Kandinsky "totally new possibilities, the superhuman force of color in itself".

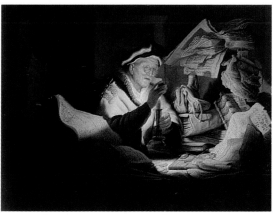

▼ Odilon Redon, *The Druidess*, c.1893, Woodner Family Collection, New York. Here, blue is used as a symbolic color with powerful, evocative force.

► Kandinsky, *Chocolats Extra*, manifesto 1897, Staatliche Museen, Berlin. With its Symbolist style, this work is a unique piece in the artist's production.

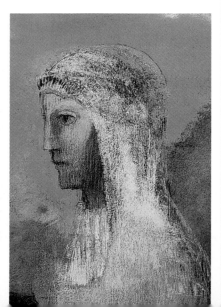

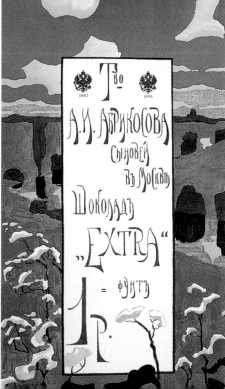

17

A "parallel" reality

The last decade of the century was the most explosive. In three great European cultural capitals (Munich, Vienna, and Berlin), different groups of artists loudly expressed their dissatisfaction with the academic world. Opening up untold new ground, the Secessions provided arenas where the most varied of experiments could take place. The dominant movement was Symbolism, in literature as well as other art forms. The phase of Realist culture was over, and attention was turned to the discovery of a dimension parallel to reality, where thousands of possible forms of human expression can be found – a dimension that the eye cannot see but the mind can grasp. The debt to philosophy and science was undeniable: psychology, psychiatry, optics, and physics were the main disciplines involved in the dynamics of this unrivalled cultural change. For example, the advancement of studies in optics revealed fundamental physiological truths about the process of vision, while the study of color offered further opportunities for analysis. Besides Symbolism, the Pointillist Post-Impressionists were emerging, such as Georges Seurat and the Italian painter Giovanni Segantini.

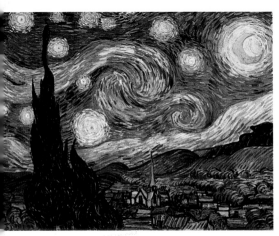

▲ Vincent van Gogh, *Starry Night* 1889, The Museum of Modern Art, New York. The highly original van Gogh produced powerful works.

▶ Paul Gauguin, *The Vision after the Sermon*, 1888, National Gallery of Scotland, Edinburgh. Gauguin was one of the most important of the Symbolist painters and a key influence on younger generations. His style, which he described as "Synthetist-Symbolic", opened up new dimensions to artists that followed.

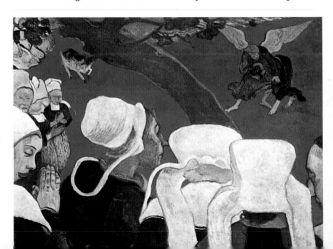

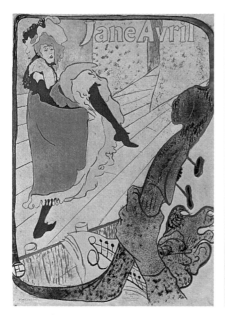

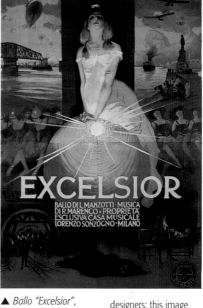

▲ Henri de Toulouse-Lautrec, *Jardin de Paris: Jane Avril*, poster, 1893. This French painter was regarded as one of the inventors of the advertising poster. His style is unmistakable.

▲ *Ballo "Excelsior"*, poster, 1880–1890, Civico Museo Bailo, Treviso. Italy had its own gifted poster designers; this image advertises a famous dance, held in Paris on December 31, 1899.

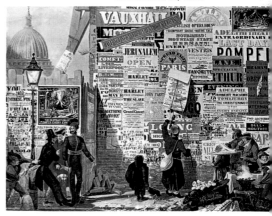

▶ John Parry, *Fantasies of a Bill-Sticker*, 1855, Victoria & Albert Museum, London. Like photography, advertising became more common in the second half of the 19th century, along with the growth of commerce. The practice of putting public notices or posters on vehicles or on the walls of houses was already widespread. Initially, the message was confined to plain text; later, pictures were added and bigger characters captured more attention. This mid-19th-century image shows an exaggerated situation that would become reality within a short space of time.

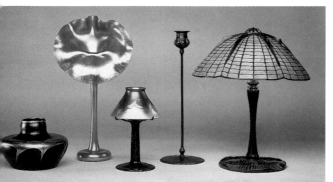

◀ Tiffany vases and lamps, 1896–1906, British Museum, London. The American Louis Comfort Tiffany created new stained glass techniques.

19

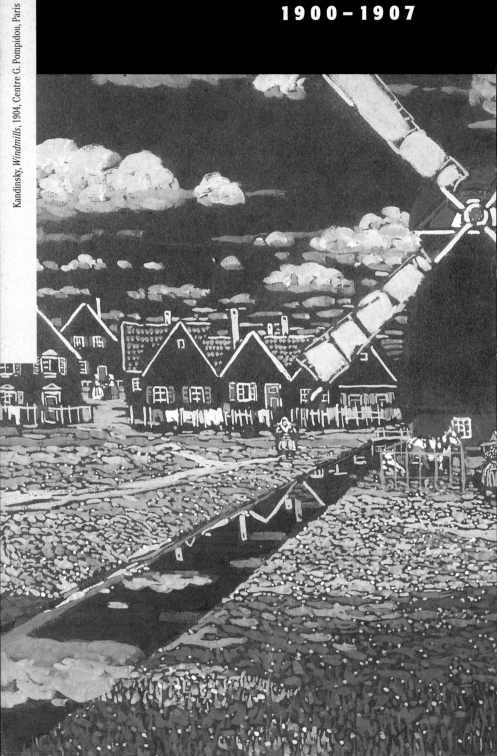

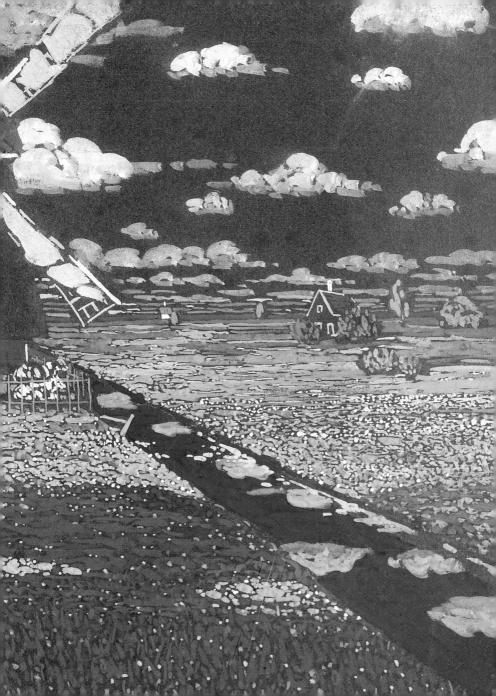

The move
to Munich

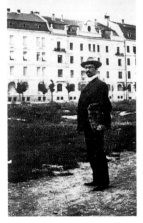

▲ Photograph of Kandinsky as a student in Munich, Centre G. Pompidou, Paris. Although he disliked life-drawing, he understood its importance, and his years of study in the city had a deep and lasting effect on him.

In 1896, backed by the confident support of his father, Kandinsky decided, with his somewhat reluctant wife, to move to Munich. The city was preferable to Paris because of the longer history of cultural relations between Russia and Germany. Furthermore, since 1892, this vibrant city had been the focus for the first of the Secessions. The Secessions expressed the gulf between some of the younger artists and the academic traditionalists, and aimed at a renewal of art in all its forms and in its relationship with society. In Munich, Kandinsky attended the school of Anton Azbé, where he studied drawing, followed by academic lessons with Franz von Stuck, with whom he learned what it meant to create a "complete" work of art. Settled in the suburb of Schwabing with a group of other artist friends, he became a founder of the avant-garde society the Phalanx. This brought to Munich work by Claude Monet, Henri de Toulouse-Lautrec, Paul Signac, Félix Vallotton, Alfred Kubin, Lovis Corinth, and Ignacio Zuloaga y Zabaleta. However, Phalanx ultimately lacked public support and Kandinsky dissolved the association in 1904.

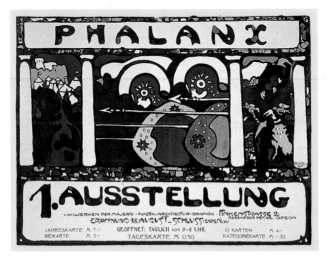

◄ This poster was designed by Kandinsky in Art Nouveau style for the first Phalanx exhibition (1901); he became president the following year. The association set out to challenge art of a Realist and conservative style.

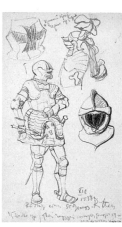

▲ Kandinsky, *Old City II*, 1902, Centre Pompidou, Paris. One of a series, this work is a pleasing landscape made up of distinct blocks of complementary colors. Forms have been simplified in the extreme.

▶ Kandinsky, drawings of knights from sketchbook 341, Lenbachhaus, Munich.

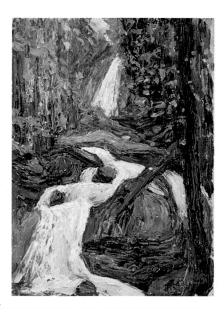

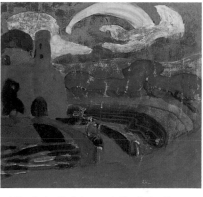

◀ Kandinsky, *Kochel – Waterfall I*, 1900, Lenbachhaus, Munich. The influence of the Post-Impressionist style emerges clearly here.

▲ Kandinsky, *The Comet (Night Rider)*, 1900, Lenbachhaus, Munich. The dreamy quality of this picture is particularly marked.

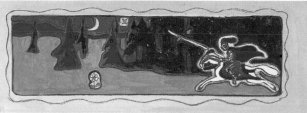

◀ Kandinsky, *Twilight*, 1901, Lenbachhaus, Munich. Here, a knight and his steed gallop headlong through the night; the subject was to remain a favorite with the painter throughout his long career.

End of an era

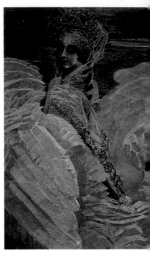

▲ Michail Vrubel,
Princess-Swan,
1900, State Tretyakov
Gallery, Moscow.
This outstanding
Russian painter and
designer was important
for his Symbolist,
anti-naturalist style.

This was a period of important decisions for Kandinsky, and a time of political change in the world. Edward VII succeeded to the throne of England, Theodore Roosevelt became president of the United States, and Giovanni Giolitti became president of the Italian Council of Ministers. In 1901, the first Nobel prizes were awarded for physics, chemistry, medicine, literature, and peace. In the literary world, a succession of important masterpieces was published: in 1901, Thomas Mann produced *Buddenbrooks*, Jack London *The Call of the Wild*, Colette the *Claudine* novels, and Antonio Fogazzaro *The Saint*, and, in 1902, the Italian philosopher Benedetto Croce published *Aesthetics*. Repeating the pattern of the 18th century, in the second half of the 19th century applied arts and interior decoration flourished, fostered by the upper classes. The great capitals and larger cities of Europe, where large sums of money circulated, now became important centers for the production and distribution of a diverse array of objects – all linked by the cultural phenomenon of modernism.

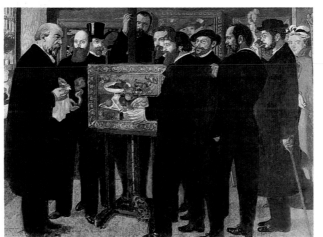

◀ Maurice Denis,
Homage to Cézanne,
1900, Musée d'Orsay,
Paris. Denis belonged to
the Nabis group, whose
work was inspired by
Gauguin's expressive
use of color. The Nabis
were also conscious of
the lessons of Cézanne,
the first to affirm that
one should not imitate
nature but "enter" it.

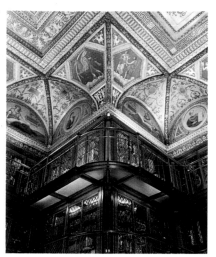

◀ At the height of the 19th century, eclecticism in interior decor triumphed in the United States as well as Europe. Shown here is the interior of the Pierpont Morgan Library in New York, a prestigious site built in 1903–1906. All the classic stylistic elements were used in its decoration.

▶ Nielsen, candelabrum in pewter and iron, 1901–1902, British Museum, London.

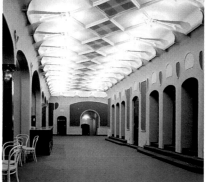

◀ The interior of the München Schauspielhaus in Munich, rebuilt by Rimerschmidt in 1901.

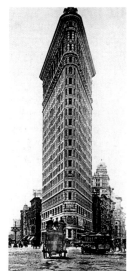

▼ The Creole Band of Joe "King" Oliver was one of the wildest blues bands in America: a new syncopated "disharmony" had arrived.

▶ At the corner between two of the busiest streets in Manhattan, the visually striking Flat Iron Building in New York (1902) is the oldest skyscraper in the city. Innovative engineering ideas were demonstrated in its light and dynamic structure.

Sketch for Achtyrka

Dating from about 1901 and now in the Lenbachhaus in Munich (one of the most important collections dedicated to Kandinsky), this work depicts the home of the artist's cousins.

▼ There are numerous works depicting this part of the Ukraine. The style has elements of Realism and Impressionism, the reflection created through the compact application of pure color.

▶ Claude Monet, *Vétheuil*, 1901, Pushkin Museum, Moscow. Master of the combined effects of light and color, the French painter sets the horizontal line of the bank high on the canvas (which is squared in order to capture the attention of the observer). The painting shows a place on the Seine that Monet knew well and found particularly inspirational. The color is applied in small dabs, vibrant with luminosity, an exultation of pink, green, and blue that creates a convincing – and very beautiful – physical effect.

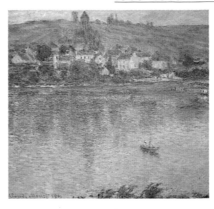

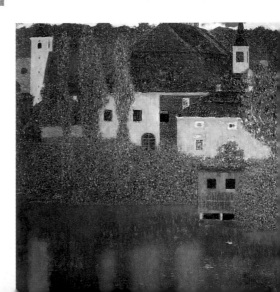

◀ Paul Sérusier, *The Talisman*, 1888, Musée d'Orsay, Paris. This canvas, a manifesto for the work of the Nabis group, is small in size (27 x 22 cm/10½ x 8½ in), and executed in the style of Gauguin. The convincing mirror of water is entirely built up of large areas of color, with an approach to tone that indicates little concern for realism. The theorist in the group, Maurice Denis, maintained that "a picture…before becoming anything else is essentially a flat surface covered with colors assembled in a certain order to please the eye". This concept, which reveals the influence of Gauguin, demonstrates how the idea of abstraction was already advancing with conviction in the second half of the 19th century.

▶ Gustav Klimt, *Kammer Castle on the Attersee I*, 1908, Národní Galerie, Prague. The Viennese painter Klimt also preferred the squared format in his series of landscapes devoted to the beautiful environs of Salzburg, which he visited on a number of occasions. The viewer feels projected into this silent and muffled world, where the color, spread so concisely, evokes an almost magical atmosphere. This, among other things, is close to various principles expressed in the philosophical-literary field, where it is maintained that it is within nature that man can find himself.

1900–1907

Early experimentation

▲ Gabriele Münter, *Portrait of Kandinsky*, 1906, Lenbachhaus, Munich. A student at the Phalanx art school, Gabriele Münter became Kandinsky's new companion.

The years 1901 to 1904 saw Kandinsky's devotion to four different artistic categories: "small oil studies" (lined cardboard with color spread with a spatula); "colored drawings" (painted in tempera on small pieces of thick black card, the subjects generally inspired by the Middle Ages); "paintings" (more complex works on canvas); and "woodcuts", more than 40 of them, the start of his graphic work. The artist wanted to move beyond the limitations of three-dimensional representation: he therefore turned his critical attention to contemporary modernism and to the pictorial traditions of years gone by – "no longer having a real existence", he said, they could give him "freer pretexts in the use of color than I felt in myself". With his capacity for observation and thirst for novelty, he focused on the Symbolist work of Russian artists of the late 19th century, on the German Middle Ages, with which he felt he was "spiritually in tune", and on old Byzantine paintings. In the magazine *The World of Art*, fellow Russians Diaghilev and Bakst encouraged new appreciation of folklore and Russian medieval culture. Kandinsky was moving towards a style that combined the romantic longing of making color the driving force with a progressive distancing of the laws of optical vision and reality. This development of style coincided with some important travel: he visited Liguria, Tunisia, Paris (where he stayed a year), and Berlin, where he arrived in September 1907.

◀ V. Tchekhovsky, *Photograph of Kandinsky*, 1904, Centre G. Pompidou, Paris. This photo shows the young Kandinsky during his Munich period. He was invited to teach at the School of Applied Arts in Düsseldorf, but declined the post in order to devote himself to his own art.

◀ Kandinsky, *In the Wood*, 1904, Lenbach-haus, Munich. The strange light creates a splendid effect of mystery around this solitary knight, who is shown crossing a magic wood. The blues and greens emphasize the impression that this could be a dream.

▲ Franz Marc, *Figure*, 1907, Folkwang Museum, Essen. Marc had loved horses since childhood and they became one of his favorite subjects. Here, the brushwork is loose, following a wavelike motion, and the color is thickly applied.

▼ Kandinsky, *Ville Arabe*, 1905, Centre G. Pompidou, Paris. Highly sensitive to color, the artist had a keen under-standing of the role of the warm North African light in intensifying forms. This scene has a strange, unreal quality.

◀ Kandinsky, *Old Russia (Russian Scene – Sunday)*, 1904, Centre Pompidou, Paris. This is one of the most important works from the artist's first artistic phase. Flat, unnatural colors and simplified, synthetic forms lend the scene an evocatively magical atmosphere.

▲ Kandinsky, *Night*, 1903, woodcut, Lenbachhaus, Munich. This is one of many fairytale images that filled Kandinsky's paintings of the Munich years.

29

The birth of the avant-garde

▲ Henri Matisse, *Open Window*, 1905, New York, Private Collection. An extraordinary painter, Matisse contributed to the creation of the first European avant-garde movement, Fauvism.

At the beginning of the 20th century, the first avant-garde movements were establishing themselves. These groups were made up of young artists who sought bravely to uphold new values and styles. Tired of the old Europe, many found sources of inspiration in non-European cultures, with their absence of the principles of classical beauty that had dictated European taste and culture for so long. Avant-garde movements developed in Russia as well, particularly in the second decade of the century. Exposed to Cubist and Futurist influences, artists developed their own creative independence, reacting both to industrial developments and turbulent political change. Other artistic and scientific achievements of this period included the first recording of an opera on disc, *Ernani* by Verdi; the Wright brothers' first engine-powered flight; the founding of numerous car firms; work on the development of synthetic fibres; the inauguration of the Sempione rail tunnel; the establishment of iron and steel plants in the industrialized nations; and the first Tour de France cycle race and Milan–San Remo rally.

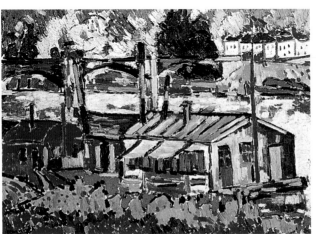

◀ Maurice de Vlaminck, *The Bridge at Chatou*, 1906, Musée de l'Annonciade, St-Tropez. Vlaminck was a member of the Fauves, a group that emerged in 1905 following the Salon d'Automne exhibition. The group set out to challenge traditional, academic art with a strongly anti-realist language of color.

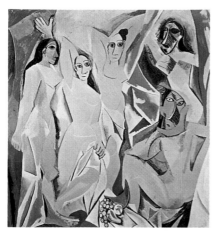

▼ Fang, *Betsi*, wooden sculpture, Gabon. Primitive art influenced the aesthetic attitudes of many 20th-century art movements.

▼ Sigmund Freud (1856–1939) was the pioneering Austrian neurologist responsible for the development of studies of the unconscious. His work led to the founding of a new discipline: psychoanalysis.

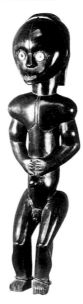

▲ Pablo Picasso, *Les Demoiselles d'Avignon*, 1907, Museum of Modern Art, New York. This canvas is usually regarded as the starting point of Cubism, originated by Picasso and Georges Braque, which involved the attempt to represent three-dimensional images on a flat surface. The Spanish artist Juan Gris would also join the group.

◄ Pictured here is the famous Ford K Touring of 1906. At the end of the 19th century, the automobile industry was already established and developing rapidly.

▶ The female form has proved to be an enduring subject for artists over the centuries: this vase by Walter Crane was inspired by ancient art. Pictured far right is an early 20th-century dressmakers, where delicate ladies don sumptuous and decorative clothes.

Windmills

Kandinsky spent some time in the Netherlands during this period; he painted this work in 1904, and it is now in the Centre G. Pompidou, Paris.

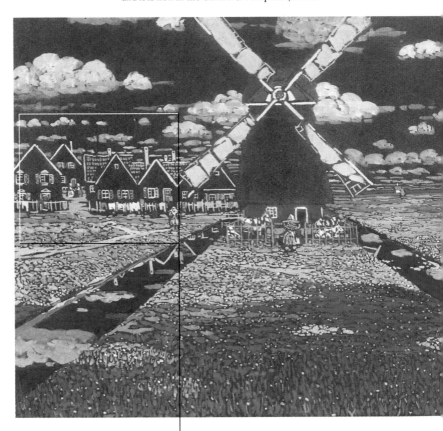

▶ The style echoes the trend widely used by European artists at that time: it is extremely detailed, with concise, dotted brushwork. Stripped of any framework of graphic composition, it illustrates Kandinsky's anti-academic theories of the late 19th century.

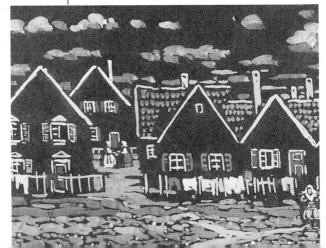

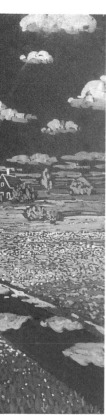

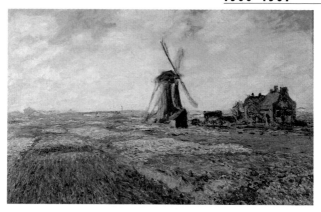

▲ Claude Monet, *Windmills (Fields of Tulips)*, 1886, Musée d'Orsay, Paris. The result of a trip to the Netherlands in April and May 1886, this luminous painting shows how Monet instinctively perceives the spirit of a land so different from his native France. He produces an open panorama gleaming with color, under a sky of changeable light and disintegrating clouds. Cold colors dominate the upper part of the picture, hot colors the lower half. The composition is driven by just two lines, the horizontal and the diagonal, and the use of verticals is reduced to a minimum.

► Vincent van Gogh, *Plots of Land at Montmartre*, 1887, Stedelijk Museum, Amsterdam. This is among the finest of van Gogh's pictures of Paris, utterly faithful to the place that he knew. His intention was not to reproduce this place he knew so well, but to feel close to the subject. The result is remarkably modern and vibrant.

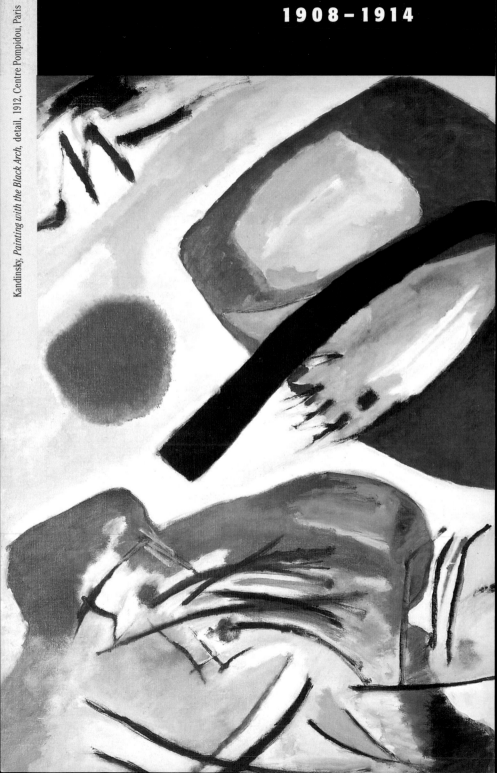

Kandinsky, *Painting with the Black Arch*, detail, 1912, Centre Pompidou, Paris

The genius period

Towards the abstract

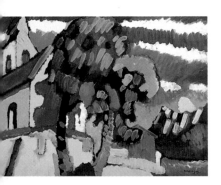

▲ Kandinsky, *Riegsee – Village Church*, 1908, van der Heydt Museum, Wuppertal.

For Kandinsky, the time he spent in Berlin (from September 1907 to April 1908) proved to be more important than his visit to Paris the previous year. In October, he met the Austrian philosopher Rudolf Steiner, founder of anthroposophy, the principles of which Kandinsky would later explore in his book *On the Spiritual in Art*. Sadly, all the work he produced in Berlin has been lost: eight paintings and six "colored drawings", which experts believe would have shown the evolution of the painter's style during that period. Subsequently, Kandinsky was active in Murnau, a small village in the Bavarian Alps, where he was invited by Alexei von Jawlensky. Every trace of Jugendstil (Art Nouveau) decorativism was now eliminated from his work, allowing the primary force of color to explode through. The artist also modified his brushwork, modelling himself on the Fauves, whose work had impressed him during his time in Paris in 1906. Aware that he was now in a highly stimulating environment, in 1909 he founded the New Artists' Association. The movement was based on the idea of the "inner drive" of painting and the development of Expressionism.

▶ Kandinsky, *Crinolines*, 1909, Guggenheim Museum, New York. Here, the subject is the frivolous world of society (a theme the artist would return to later in his career), rather than nature. Contact with composers and dancers and an interest in music were key factors in Kandinsky's artistic development during this period: he devoted several works to the links between sound and color.

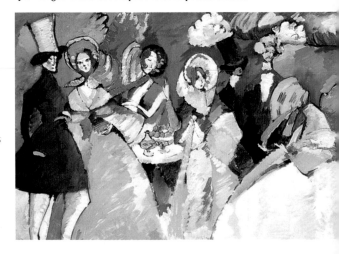

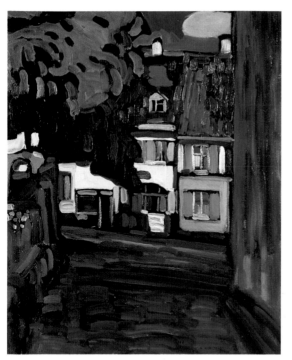

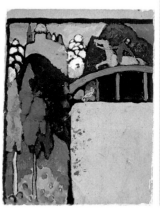

◄ Kandinsky,
*Murnau – Houses on
the Obermarkt*, 1908,
Thyssen-Bornemisza
Collection, Madrid.
Here, blue and black
confer drama and
"a note of agonizing
sadness".

▼ Kandinsky, *The Blue
Mountain*, 1908–1909,
Guggenheim Museum,
New York. Blue,
according to the poet
Novalis, is the color
of the spirit, because

by infinite degrees it
raises matter to the level
of transcendence. There
is still a subtly Symbolist
vein in this work, a sense
of movement repeated
in slow motion.

▼ Kandinsky,
Improvisation VII,
1910, State Tretyakov
Gallery, Moscow. Here,
the stress is placed
on diagonal movement
and distortion.

▲ Kandinsky,
*Landscape with Rider
on a Bridge*, 1908–09,
Lenbachhaus, Munich.
Little now remains of
the Kandinsky knights
of the early years.

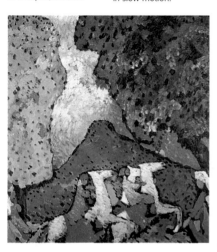

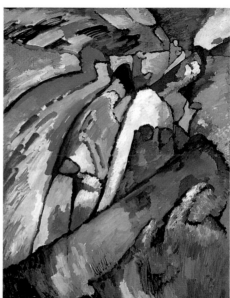

Modernity advances

BACKGROUND

W hile Kandinsky was going through what became known as his "genius period", other Russians were being honored in the eyes of the world. Among them were Ivan Pavlov, who was awarded the Nobel prize for medicine, and Sergei Diaghilev, who took the Ballets Russes to Paris to triumphant critical and public acclaim. Important political changes were taking place: in October 1905, Russia became a constitutional monarchy and, on May 10, 1906, the first Duma (the new parliament) was convened. Everywhere modernity was advancing, despite the most entrenched resistance – for example, Pope Pius X required an oath of antimodernism from the clergy. There were significant landmarks in literature and philosophy, with works published by Pascoli, Gide, Saba, London, Bergson, Besant, Leadbeaters, and Worringer. In music, Arnold Schoenberg composed *Five Pieces for Orchestra*, and Igor Stravinsky staged the ballet *The Firebird* in Paris. Henri Bergson, the philosopher beloved of the Symbolists, argued in his *Creative Evolution* (1907) that evolution must be explained in terms of a driving force towards greater individuality and complexity. He called this drive the *élan vital*, or "life force". Meanwhile, Wilhelm Worringer declared in *Abstraction and Empathy* (1907) that "the original artistic impulse has nothing to do with the reproducing of nature.It aims at pure abstraction".

▲ Oskar Kokoschka, *Pietà*, 1908, Österreichisches Museum für Angewandte Kunst, Vienna.

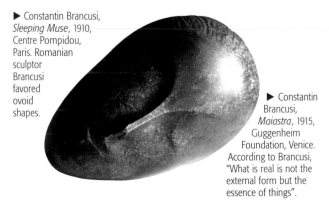

▶ Constantin Brancusi, *Sleeping Muse*, 1910, Centre Pompidou, Paris. Romanian sculptor Brancusi favored ovoid shapes.

▶ Constantin Brancusi, *Maiastra*, 1915, Guggenheim Foundation, Venice. According to Brancusi, "What is real is not the external form but the essence of things".

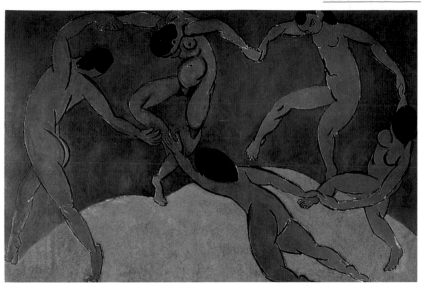

▲ Henri Matisse, *La Danse*, 1910, State Hermitage Museum, St Petersburg. Matisse had always been attracted to sinuous movement. Here, the rhythm and harmony of this silent dance are the equivalent of the rhythm and harmony of composing a work of art.

◄ *Cycladic Idol*, 2000 BC. The effect of the stark, simple form of this ancient work is both pure and powerful.

▲ *Mask*, Kwele art (Congo), Private Collection, Milan. In the synthesis of form and line in this mask, we can detect a sense of the modern concept of the abstract.

Landscape with Tower

Painted in 1908, this work (now in the Pompidou Centre in Paris) belongs to a series of oils painted on increasingly large pieces of card. It is one of the masterpieces from Kandinsky's "genius phase" at Murnau.

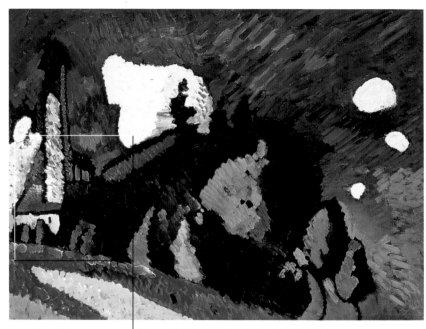

▶ Under a sky heavy with blue, Kandinsky depicts a wood dominated by greens. A minuscule building, with a high chimney, sticks out from the trees and overlooks the ploughed fields. The color, spread with compact brushstrokes, dominates the picture, but effects of light and shade and space and volume also contribute to the powerful atmosphere. There is a sense of the unnatural – this is the road to abstraction.

► Karl Schmitt-Rotluff, *Mittag im Moor*, 1908, Landesmuseum, Oldenburg. This work encapsulates the canons of Expressionist style: nature is radically altered as volumes and lines are cancelled out and natural colors are overturned by a palette that is vivid and unnatural. The dominant red is typical of the burning emotional charge that runs through the work of German Expressionists.

◄ Georges Braque, *Houses at l'Estaque*, 1908, Kunstmuseum, Berne. Cubists such as the pioneering artist Braque made use of a very limited range of colors and created a sense of stillness or slow distortion – in strong contrast to the vibrant color and energy of many Expressionist works. Cubists never pushed themselves to the point of abstraction, and, while they continually experimented with new formal solutions, they never completely abandoned the figurative.

► Alexei von Jawlensky, *Summer Evening at Murnau*, 1908–1909, Lenbachhaus, Munich. Here, Kandinsky's compatriot Jawlensky favors wide planes and a calmer atmosphere in his exploration of abstraction. However, as in Kandinsky's work, color is the primary element.

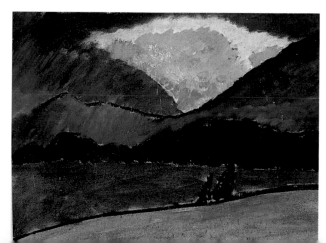

41

Art as a spiritual value

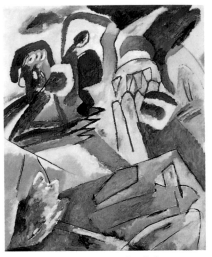

▲ Kandinsky, *Improvisation 18*, 1911, Lenbachhaus, Munich. This is one of Kandinsky's numerous *Impressions*, all of which date from 1911.

F rom 1909 onwards, Kandinsky divided his work into *Improvisations*, *Impressions*, and *Compositions*, which he saw as stages in the progression towards abstraction. He was increasingly convinced that nature and exterior forms represented an obstacle in the path of the elevation of the human spirit. Forms had therefore to be eliminated, to allow the spirit to reach the perfect liberty of the flow of life, which continually feeds the imagination with sounds and colors. Kandinsky explored these ideas in contributions to various Russian and German magazines, but his most important publication was *On the Spiritual in Art*, a collection of theoretical reflections and an important stage in his philosophical research on color. The same commitment characterized his work on set design: he had a passion for musicians like Beethoven and Schoenberg. On January 1, 1911, he met Franz Marc, with whom he was to publish an Almanac of essays and images, in which popular, primitive, and contemporary art could be seen together.

▼ Kandinsky, *Lyrical*, 1911, Museum Boymans van Beuningen, Rotterdam.

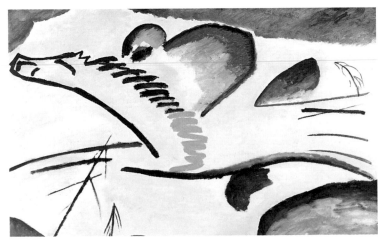

◄ Kandinsky, *Improvisation 28 (2nd version)*, 1912, Solomon R. Guggenheim Museum, New York. The *Improvisations* were "principally unconscious expressions…of events of an interior character, and therefore impressions of the 'inner nature'".

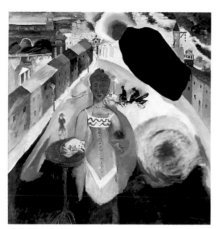

► Kandinsky, *Lady in Moscow* 1912, Lenbachhaus, Munich. Here, the irregular dark shape seems to threaten the aura of the woman.

▼ Kandinsky, *Improvisation 19,* 1911, Lenbachhaus, Munich. This *Improvisation* seems to describe a struggle between matter (the red) and spirit (the blue).

▼ Kandinsky, *Impression VI*, 1911, Lenbachhaus, Munich. Here, the artist eliminates detail and depersonalizes the human character, allowing the bodies to become first color, then "inner impulse".

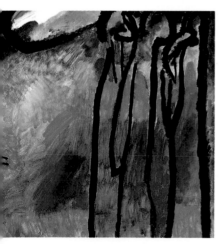

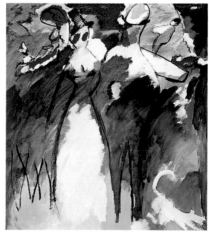

The Blaue Reiter

▲ Franz Marc and August Macke, *Paradise*, 1912, Westfälisches Landesmuseum, Münster. This large work (400 x 200 cm/ 157½ x 78¾ in), painted in oil on plaster, reveals the artists' debt to Gauguin and Symbolism. The two artists would later develop their styles in different directions.

In October 1911 in Munich, Kandinsky and Franz Marc founded the group Der Blaue Reiter (the Blue Rider), an event regarded by art historians as one of the most important of the 20th century. Two great passions were the stimuli: horses and the color blue. The Blaue Reiter "Almanac", a collection of essays and illustrations published in 1912, set out to formalize a vision of art conceived as existential experience. It united not only the personal theories of its two founders, but also incorporated concepts previously expressed by Goethe, Schiller, Delacroix, Chevreul, Wagner, Steiner, and Worringer. In *On the Spiritual in Art*, Kandinsky wrote: "Our soul is re-awakening from a long period of materialism…but is still a prey to nightmare…which arises from the lack of any faith." This faith is now identified with the study of the spirit, which can only be reached by drawing on "breath of the platonic universal soul…". The task of creating contact without being trapped by the weight of the exterior falls to the artist: "Beauty arises from inner psychic necessity…Color is the keyboard. The eye is the hammer. The soul is a piano with many strings. The artist is the hand which, touching this or that key, makes the soul vibrate…". With a critical view of Impressionism and Post-Impressionism, the Blaue Reiter hoped to express spiritual realities by going "behind the veil of appearances".

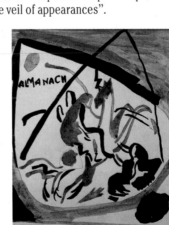

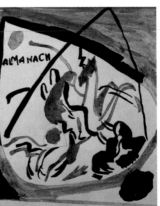

◄ Far left: Kandinsky, *Paradise*, 1911–1912, Lenbachhaus, Munich. Here, the black blobs represent negative thoughts.

◄ Kandinsky, design for the cover of the Blaue Reiter "Almanac", 1911, Lenbachhaus, Munich. Official critics reacted angrily to the publication of the group's "Almanac".

◄ Kandinsky, *Yellow Horse*, 1909, Lenbachhaus, Munich. Kandinsky and Marc collaborated on the two Blaue Reiter exhibitions and the "Almanac".

▶ Franz Marc, *The Dream*, 1911, Thyssen-Bornemisza Collection, Madrid. The girl sleeps and dreams in a state of beatitude. A menacing lion, painted in yellow, knows he cannot make a move, because she is protected by the two horses on the right – symbols of good.

▼ Kandinsky, *The Cow*, 1910, Lenbachhaus, Munich. This notable masterpiece from the artist's Munich period shows his interest in nature and the countryside, in the daily life of people who inhabit it. Luminous white and yellow dominate, and perspective vanishes in the face of thick, flat brushstrokes.

▼ Franz Marc, *Yellow Cow*, 1912, Lenbach-haus, Munich. This canvas is among the most individual in modern painting. We look kindly on this gigantesque Bavarian bovine who, despite her bulk, jumps and dances as though she were a goat. She even seems to be smiling, vital in a land full of energy. The setting, with its flattened colors, is notably plastic.

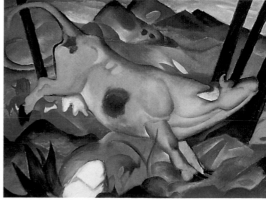

Impression 5 – Park

This warm and powerful work, dating from 1911 and now in the Pompidou Centre in Paris, is a key work from Kandinsky's most creative period. Painted in oils, it was preceded by several pencil studies.

► Physical reality has been almost completely deconstructed. The only dominant graphic element is the black outlines, which economically trace the barest of shapes in the park. An isolated tree stands out on the reddening hill.

▼ Alexei von Jawlensky, *Solitude*, 1912, Museum am Ostwall, Dortmund. Landscapes and portraits were the preferred subjects of Jawlensky. This is an interesting example of his pictorial language: heavy contour lines weigh down the natural forms, allowing an alienating sensation and gloomy atmosphere to emerge. The use of white does not communicate a sense of tranquillity, and we are aware of subtle disquiet.

▶ August Macke, *The Storm*, 1911, Saarland Museum, Saarbrücken. Macke was another key member of the Blaue Reiter group. He depicted natural subjects in a style that blended the reflections of Kandinsky with the suggestions of Matisse, making his work less spiritual and more decorative.

The philosophy of the "vital impulse"

▲ Auguste Perret, House at Rue Franklin 25 bis, Paris, 1903.

In the closing decades of the 19th century, the old world order was undermined by a series of natural and political events. While the industrialized nations fought to maintain the status quo, which allowed them to keep economic and financial affairs stable on an international scale, countries in the process of industrialization only succeeded with difficulty in making any impact on the world stage. The European powers pursued imperialist policies, bringing new areas of the world under their control; while in Europe, the Balkan nations were at war with one another. The advance of Socialism and Communism coupled with the emergent women's movement raised questions about the very fabric of society. As old certainties collapsed, new ideas emerged in the theories of eminent scientists, philosophers, and psychologists. Albert Einstein's discoveries concerning the nature of matter and energy and Sigmund Freud's ideas about the unconscious mind shattered traditional beliefs. The purely irrational role of instinct was re-evaluated, the "reality" of spirit and mind was explored, and the concept of "absolute truth" was examined critically, asserting the relativity of knowledge.

◄ Otto Wagner, Maiolikahaus, 1899, Vienna. Situated on the Ringstrasse, this important building was decorated with tiles by Gustav Klimt.

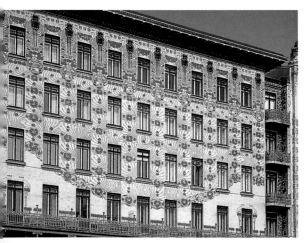

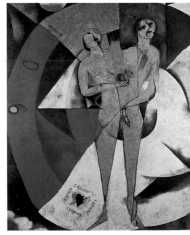

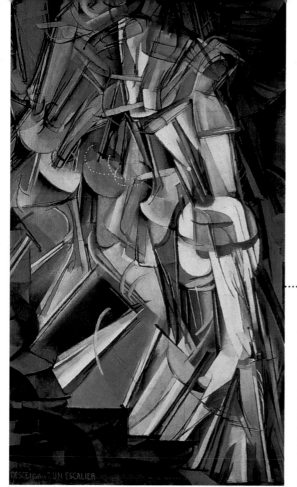

◀ Marcel Duchamp, *Nude Descending a Staircase, No. 2*, 1912, Museum of Art, Philadelphia. This work, shown in New York in 1913, unsettled the American public and conservative critics. In a single picture there is abstraction, motion, and breakdown.

Futurism

Originally a literary trend, Futurism was the first Italian avant-garde art movement, its ideas disseminated widely throughout Europe by the use of manifestos and public demonstrations. Key ideas included a desire to be free of the past; the glorification of speed and violence; and the celebration of modernity and new technology. The movement was to absorb all areas of culture, including cinema and music.

◀ Marc Chagall, *Homage to Apollinaire*, 1911–1914, Stedelijk Van Abbe Museum, Eindhoven. The hugely influential French poet and dramatist was a precursor of Surrealism.

▶ Carlo Carrà, *Funeral of the Anarchist Galli*, 1911, Museum of Modern Art, New York. The atmosphere of this work is powerful and intense – as befits the highly charged political event it represents.

1908–1914

From city to metropolis

The second half of the 19th century had seen the triumph of eclecticism both in Europe and in the United States. It was expressed in a variety of styles (including those inspired by antiquity, the Middle Ages, and the Orient) and in a series of important structural innovations in architecture. Cities also evolved during this era, with huge numbers of people drawn to areas that were increasingly prosperous from the development of industry. In the larger European capitals and cities, town planning schemes began to be applied. Historic centers were cleared of their ancient buildings, roads, and squares to make room for new constructions, both public and private; city transport networks were installed above and below ground; traffic arteries were created for those "mechanical monsters" – cars – that were "more beautiful than the Victory of Samothrace" in the eyes of the Milanese Futurists. Movement, speed, chaos, industrial materials, glass, and transparency: Antonio Sant'Elia, working in 1910 in Lombardy in northern Italy, could already see the future.

◄ Antonio Sant'Elia, *The New City*, 1914, Museo Civico, Como. Here, Sant'Elia envisages a futuristic city on several levels.

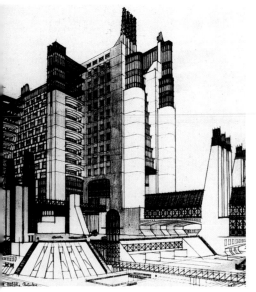

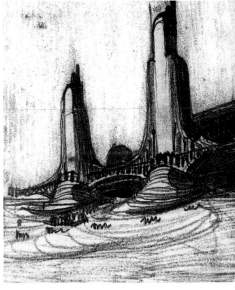

◄ Ulisse Arata, Casa Berri-Meregalli, 1914, Milan. This is an elegant example of Milanese Art Nouveau. The interior of the building reveals the characteristics of heavier decorative elements inspired by the most bizarre and fantastic Gothic examples. By the 1920s, Italian modernism had died out and the mood had turned towards classic forms.

▼ Antonio Sant'Elia, sketch for the new Stazione Centrale in Milan, 1913–1914, Monti collection, Milan.

▲ Iakov Tchernikhov, Composition with different architectonic forms, 1930, Tchernikhov Collection.

▼ Antonio Sant'Elia, architectural study, 1913, Accetti Collection, Milan.

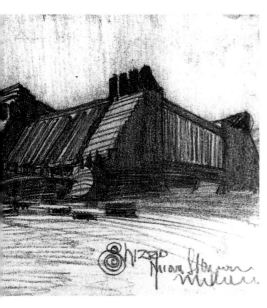

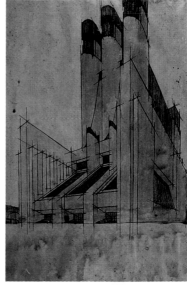

The final years in Munich

The use of the diagonal to create movement was typical of Marc's work.

This was an extraordinary time for Kandinsky. His work could be placed on the same level of importance as Matisse, Boccioni, and Picasso, and he was proving to be a worthy successor to Cézanne, whom the Russian defined as a "prophet". His ideas were known through his exhibitions, his writing, and his criticism of his contemporaries, including those of his native land – where the prevailing avant-garde held rather different views from his own. Meanwhile, the Blaue Reiter (of which Klee was now a member) had held two important shows in Munich. At the second, which included 300 or so works on paper, Die Brücke, the Cubists, and several Russian artists were well represented. In 1914, the city of Munich, with its vibrant cultural life, staged the first German version of the Salon d'Automne, one of the most important art exhibitions in the history of European art. At about this time, Kandinsky also became known in New York through the photographer Stieglitz, who fostered promising young artists. In June 1913, he completed an autobiographical work, *Reminiscences*, about his artistic experiences between 1901 and 1913. However, this phase of his life was soon to end: when World War I broke out, Kandinsky, the enemy by nationality, had to leave Germany, and he returned to Moscow.

▲ Franz Marc, *Animal Destinies*, 1913, Kunstmuseum, Basel.

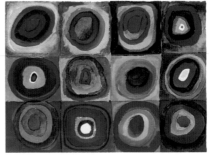

◀ Kandinsky, *Horsemen of the Apocalypse II*, 1914, Lenbachhaus, Munich. The artist was profoundly moved by biblical themes.

▲ Kandinsky, *Study of Color – Squares with Concentric Circles*, 1913, Lenbachhaus, Munich.

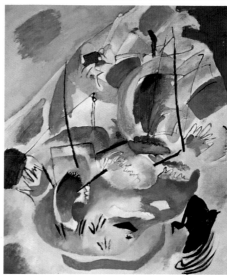

▶ Kandinsky, *Improvisation 31 – Sea Battle*, National Gallery of Art, Washington, DC. This battle of colors, where dark tones are perceived as negative, reflects the historical context of the time.

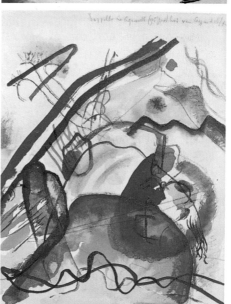

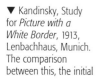

▼ Kandinsky, Study for *Picture with a White Border*, 1913, Lenbachhaus, Munich. The comparison between this, the initial idea for a work of art, and the finished article itself (right) is fascinating, revealing as it does the artist's working method.

▲ Kandinsky, *Picture with a White Border*, 1913, Lenbachhaus, Munich. Examination of colors and forms led Kandinsky to create a purely pictorial composition, in which "color and form exist in an independent way…and constitute a tonality called picture".

Between spiritualism and abstraction

By the beginning of 1914, the European political system was close to collapse. However, the military skirmishes of recent years would seem insignificant compared with the first international conflict, from which a different system would emerge. Even in the world of art, there were countless changes and diverse new influences. Among the contributions was that of Rudolf Steiner. Before founding the Anthroposophical Society in 1913, he had been the secretary of the Theosophical Society, founded by Helena Blavatsky in 1875. Theosophy was an eclectic mix of ideas derived from Hinduism, Buddhism, and other religions. According to Blavatsky, the quality of a person's inner life is visible to the sensitive in a colored "aura" that spiritually surrounds the person. In part reorganizing previous studies, in part proceeding on the basis of personal evaluation, Steiner facilitated another step towards the definitive conquest of the imaginative dimension. Meanwhile, the idea of abstraction was spreading, moulded by artists according to their own intuition.

▲ Piet Mondrian, *The Gray Tree,* 1911, Gemeentemuseum, The Hague.

◄ Piet Mondrian, *The Sea,* 1912, Private Collection, Basel.

▼ Piet Mondrian, *Composition 10 in Black and White,* 1915, Kröller-Müller Museum, Otterlo.

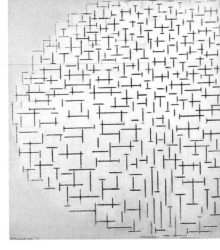

► Jackson Pollock, *Eyes in Color*, 1946, Guggenheim Foundation, Venice.

▼ Joseph Stella, *Battle of Lights,* 1913, Yale University Art Gallery, New Haven.

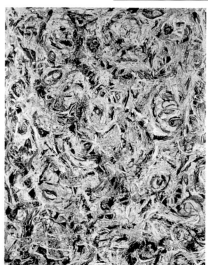

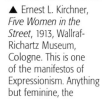

Expressionism

Expressionism was an artistic avant-garde movement born of opposition to Impressionism and incorporating the Fauves of Paris (1905), the Blaue Reiter, and the Dresden-based group known as Die Brücke (the Bridge). Its art was characterized by strong and exaggerated color ranges, linear distortions, and a lack of naturalism. In Germany, Expressionism prevailed until as late as the early 1930s.

▲ Ernest L. Kirchner, *Five Women in the Street*, 1913, Wallraf-Richartz Museum, Cologne. This is one of the manifestos of Expressionism. Anything but feminine, the subjects of this picture stand erect, almost like human columns, symbolizing a society in which woman is acquiring a position of ever-increasing importance.

55

1914: the outbreak of war

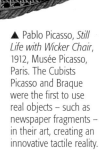

Following the assassination of Archduke Ferdinand – heir to the throne of Austria – at Sarejevo, World War I broke out on July 28, 1914. In that subtle and terrifying game of slaughter, two political line-ups faced each other: the Central Powers (principally Germany, Austria-Hungary, and Turkey), and the Allies (principally France, Great Britain, and Russia). Millions would die in trench warfare before an armistice was agreed on November 11, 1918. Other battles, certainly less bloody if equally pugnacious, were those waged by the new European art, which had absorbed the teaching of the 19th century Realist and Post-Impressionist movements and was conscious of having reached a epoch-making turning point in the concept of taste. In the chaos of these years, culture reacted in different ways, sometimes unleashing a frightening vitality and making use of all the means at its disposal – for instance in manifestos and theoretical writing – to express strong opposition to the well-established system.

▲ Pablo Picasso, *Still Life with Wicker Chair*, 1912, Musée Picasso, Paris. The Cubists Picasso and Braque were the first to use real objects – such as newspaper fragments – in their art, creating an innovative tactile reality.

◄ Alberto Burri, *Sacking With Red*, 1954, Tate Gallery, London. Decades after Picasso's first experiments with collage, the Italian artist Burri used sacking soaked in red paint – the suggestion is of blood-soaked bandages – to create this powerful work.

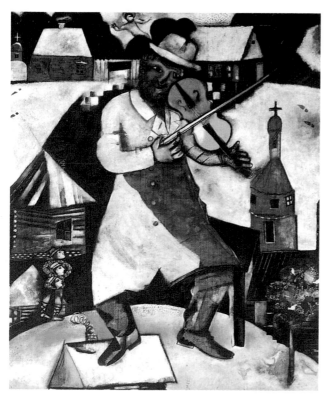

◀ Marc Chagall, *The Fiddler*, 1913, National Gallery, Washington, DC. Chagall was an important figure in European art in the early decades of the 20th century. His style was distinctive and unmistakable, halfway between fantasy and abstraction, with a use of color that revealed Fauvist influences. Part of the School of Paris, along with Modigliani and Soutine, Chagall was influenced by the most innovative art movements, including Cubism.

▼ Pictured here is the interior of the house belonging to the Moscow collector Morosov, who accumulated an exceptional collection of contemporary art. He was one of the few Russian collectors to grasp the significance of the new cultural ferment in Europe.

▼ The mythical Isotta Fraschini KM (1914), was described as "monstrous" because of the speed it could reach: nearly 130 km per hour.

Picture with Red Spot

This canvas, painted in 1914, is now on display in the Pompidou Centre in Paris. In his search for the infinite potentiality of abstraction, the artist was by this time producing work of exceptionally high quality.

▶ Robert Delaunay, *Homage to Blériot*, 1914, Kunstmuseum, Basel. Delaunay was the "heretic" of Cubism – as the poet Apollinaire put it – because he was attracted by the formal experimentation of Braque and Picasso, yet could never bring himself to abandon color, to which he attributed a strong imaginative force. His brand of Cubist-influenced abstract art was named Orphism by Apollinaire. The importance of the movement was also recognized by Klee and other members of the Blaue Reiter.

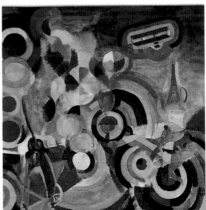

▶ Abstract art is by no means disorganized – in fact coherent order reigns in defiance of academic or naturalistic rules. As with other masterpieces of the years between 1910 and 1920 (such as *Painting with the Black Arch*, of 1912), Kandinsky invites us to lose ourselves in the magma of color, to let ourselves be transported by a wave of sensation. He described such work as "controlled improvisation", because it is charged with inner energy. In *On the Spiritual in Art*, he wrote: "Red…is a flooding and typically hot color, which works in an extremely energetic…and restless way in interiority.

Without the superficiality of yellow, which disperses in all directions, it demonstrates immense and almost conscious energy". The red spot leaps out of the blue,

contrasting with yellow – the manifestation of unstable energy. Different tones of blue, green, and red attenuate this encounter.

◀ Paul Klee, *Card Game in the Garden*, 1913, Private Collection, Switzerland. Although concerns for naturalism are apparent in this watercolor, the use of color and dissolving form indicate how far Klee had already gone beyond the confines of conventional volumetrics.

59

Kandinsky, *Picture with Three Spots*, detail, 1916, Thyssen-Bornemisza Collection, Madrid

Difficult years

Kandinsky spent the winter of 1916 in Stockholm with Gabriele Münter, working intently. He then returned alone to Moscow, and fell in love anew with his native city. The idea for a large painting dedicated to the place came to him and he wrote to Gabriele of the enormous enthusiasm that buoyed him. However, these were unsettled times and by no means the artist's most productive: his affair with Gabriele ended and financial difficulties forced him to sell most of the building in which he lived. Despite the difficulties, being in Moscow filled him with happiness. And in fact *Moscow I*, a large oil painting showing a pair of lovers seemingly floating on clouds of optimism, dates from this period. In September 1916, Kandinsky met Nina Andreevskaya, the daughter of a Tsarist colonel; her voice made such an impression (the couple spoke on the telephone before they met) that he painted a splendid watercolor for her. By February 1917, with Kandinsky now over fifty years old, the two were married.

▲ Kandinsky, *Birds*, 1916, Centre Pompidou, Paris. This watercolor, ink, and pencil work shows birds flying joyously over Moscow.

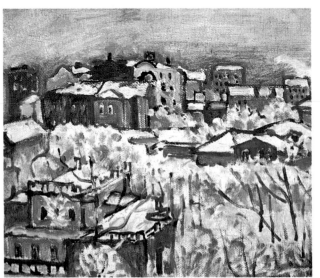

◀ Kandinsky, *Moscow – Smolensk Boulevard*, c.1916, State Tretyakov Gallery, Moscow. Reunited with his home city, Kandinsky experimented with enriching his palette and studying new harmonies. He wrote: "I paint the landscape I see from my window: in the sun, at night, when it is cloudy."

■ Kandinsky, *Untitled*, 1916, Centre Pompidou, Paris. This is one of numerous works produced during the artist's research for the painting *Red Square*: the Kremlin, heart of Moscow, is visible on the right, complete with bizarre smoking chimneys. The houses and streets create a picture of vitality and joy.

▼ Kandinsky, *Young Woman in Russian Costume*, 1902, Lenbachhaus, Munich. These small, detailed pictures demonstrate the artist's remarkable capacity for observation.

▶ Kandinsky, *Achtyrka – Nina and Tatiana on the Veranda*, 1917, Centre Pompidou, Paris. Kandinsky and his new wife spent some time in the Ukraine with his cousins, the Abrikosovs, at the property much loved by the painter.

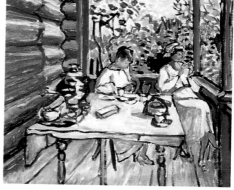

▼ Kandinsky, *Untitled*, 1915, Thyssen-Bornemisza Collection, Madrid. Painted while in Stockholm, this work forms part of a group

known as the *Bagatelles*. Kandinsky described them as depicting "figures of old Russia".

63

1915–1921

Power to
the people

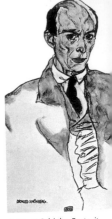

▲ Egon Schiele, *Portrait of Schoenberg*, 1917, Österreichische Galerie, Vienna. One of the greatest of all Expressionists, Schiele worked as a War Artist during these years.

While France and Germany engaged in the relentless draining of human life through trench warfare, the United States declared war on Germany after three US merchant ships were sunk by German submarines. The victory of first Germany, and then Austria, over Russia, catapulted Kandinsky's native land into total crisis. In March 1917, strikes and revolts launched by the working classes (made up of the industrial and agricultural proletariat) ended up involving the Tsarist guard: on March 16, Nicholas II was forced to abdicate. In November 1917 (October, according to the old Russian calendar), under the leadership of Lenin and Trotsky, the revolutionary Bolsheviks gained power and proclaimed the Soviet Republic, with territorial councils formed by workers, peasants, and soldiers. The entire culture was entering a new phase and the position of the artist was reassessed in the light of the new political realities. Art, it was now felt, should serve society, and as a result the aesthetic of industrial design rose in prominence. Vladimir Tatlin, who had founded the abstract art movement Constructivism in 1914, was the key figure of the Revolutionary years and at the center of the state's reorganization of culture.

▲ A smiling Billie Holiday, future jazz star.

▶ Here, an assembly with Lenin is reconstructed in a scene from *October*, directed by Sergei Eisenstein in 1927. The film recreated the chaotic events of that historic month. The Muscovite director had already produced *Strike* (1924), also dedicated to the working class.

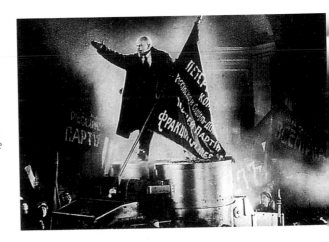

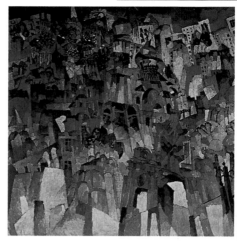

▲ Marcel Duchamp, *Fountain*, 1917, A. Schwarz Collection. In Duchamp's famously controversial piece, artistic language is completely overturned as a urinal becomes a work of art.

▲ Aristarkh Lentulov, *The Firmament – Decorative Moscow*, 1915, Russian Museum, Iaroslav. Many avant-garde artists created idealized images of Moscow.

▼ Kasimir Malevich, *Supremus 56*, 1916, Russian Museum, St Petersburg. The art movement Suprematism was launched in 1915 with a manifesto signed by Malevich and Maiakovsky.

► Below right: Ivan Puni, *Suprematist Sculpture*, 1915, Private Collection, Zurich. Suprematist artists limited themselves to a narrow range of shapes and colors.

Ready-made

The term "ready-made" was coined by Duchamp to describe a mass-produced industrial object used for artistic purposes without any alteration to its state. His first ready-made was a bicycle wheel.

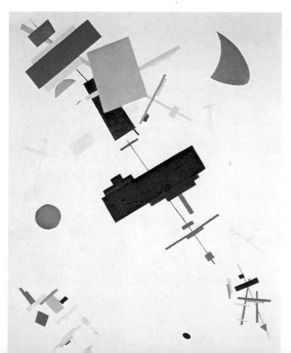

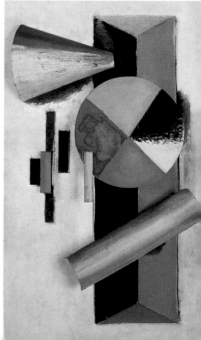

MASTERPIECES

Painting on Light Ground

This work dates from the early part of 1916, when the artist was working towards a show in Stockholm, and is now housed in the Pompidou in Paris. It is one of a handful of paintings from Kandinsky's Russian period. On a neutral background, a bombardment of color and dynamic sense of depth draw the spectator to its center.

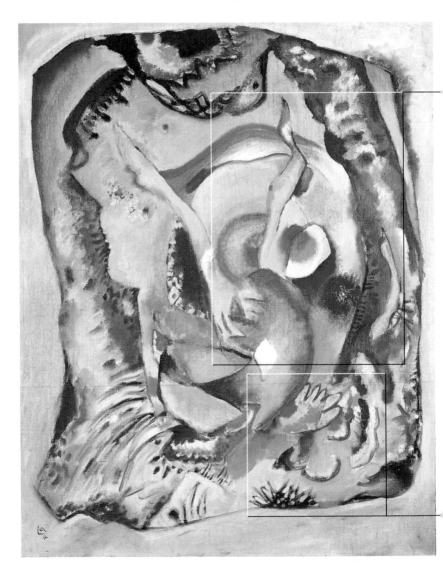

► For Kandinsky, only by giving colors and forms an autonomous dignity could the new art contribute to the growth of humankind. Beyond the limits of nature, there is *only* the vocabulary of the artist. The painter wrote: "If the number of colors is infinite, so too are their combinations infinite".

◄ Kandinsky explained: "The spectator is also too accustomed to look for the 'meaning', in other words an exterior relationship between the parts of the picture. Our era, materialist in life and therefore in art, has produced a spectator who does not know how to simply put himself in front of a painting, and looks for everything possible in the painting but does not allow the picture to work an effect on him." What counts, he said, is "the effective contact with the soul".

The politics of art

At the outbreak of the Revolution, Kandinsky's life changed drastically. From January 1918, he worked for state institutions: within the People's Commissariat of Enlightenment (Narkompros), he became part of the Department of Fine Art, headed by Vladimir Tatlin, and in October he became the director of an art workshop, which allowed him to resume the theoretical aspects of his work. He also became a director of the Moscow Museum of Painting Culture and contributed to the opening of 22 museums in various provinces, giving his own works to many of them. He also devoted himself to writing: he worked on the final stages of the publication of an *Encyclopedia of Visual Arts*, and published two articles, *Point* and *Line*, for the Moscow publication *Iskusstvo*. At this time, he produced very little practical work: no paintings, some glass work, a few watercolors, and some graphic art. Looking back at this period of state-aligned endeavor, his wife remembered: "Kandinsky was to become director of the Academy, but from the moment that he was neither Marxist nor Communist, the more important post was denied to him…". The academy benefited from his ideas, and on his departure "it drifted completely".

▲ Kandinsky is pictured here with his wife Nina in their Moscow house, with *Improvisation IV* (1909) behind them. Unlike Gabriele Münter, Nina was never part of Kandinsky's professional life, but remained a genuine and steady support to him. They had one child, a boy. Centre G. Pompidou, Paris.

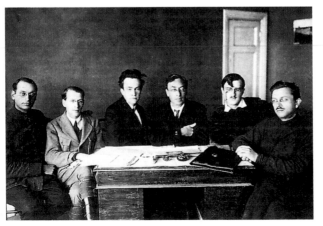

◄ Kandinsky with members of the Narkompros group. Nina recalled: "Until the death of Lenin, living standards for artists were like paradise…and Kandinsky put all his energy into finishing projects whose completion he regarded as indispensable". Centre G. Pompidou, Paris

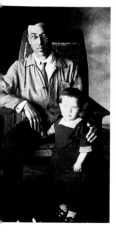

◀ Kandinsky with his son Volodya. The child died from gastroenteritis in 1920, before his third birthday.

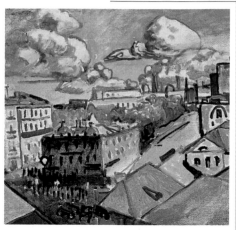

▶ Kandinsky, *Piazza Zubovsky in Moscow Seen from the window*, c. 1916, State Tretyakov Gallery, Moscow. The painter was faithful in the detail of his Moscow views.

▼ Kandinsky, *Pink Tangle*, 1918, Fondation Martin Bodmer, Bibliotheca Bodmeriana, Cologny-Geneva. This delicate watercolor and ink drawing on paper seems to have been painted with the tip of the brush The painter made numerous compositions of this kind.

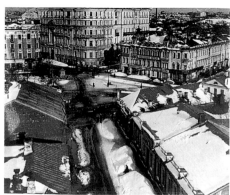

▲ Piazza Zubovsky, seen from the painter's house. This and photo below both Centre G. Pompidou, Paris.

▼ The headquarters of the Freie Staatliche Künstlerische Werkstätten in Moscow in about 1920, where the artist worked.

1915–1921

Political turbulence

A̲fter the October Revolution, events in Russia moved at an escalating pace. Peace with Germany, the country's most uncomfortable "neighbour", was sealed in March 1918, but the conditions dictated by the Germans were such that Russia risked losing a third of its population and half of its industrial plants (all located in the west). This was of particular concern to the revolutionaries, who tried to oppose the relinquishment, perhaps provoking the diplomatic and military reaction of the enemy Allies, who supported the so-called counter-revolutionary White Armies. The territorial question would only be resolved in 1921; in the meantime, the new regime concentrated on the reorganization of industry. Thanks mainly to the avant-garde movements Constructivism and Suprematism (which had emerged shortly before the Revolution), the arts supported the ideal of mechanization, geometric abstraction, and the language of the masses. Meanwhile, elsewhere in Europe, the anarchic Dada movement was flourishing.

▲ Charles Rennie Mackintosh clock, 1914, British Museum, London.

◄ Raoul Hausmann, *The Art Critic*, 1920, Tate Gallery, London. Dada artist Hausmann expressed his views in crudely satirical photomontages.

▼ Arnold Schoenberg, *The Red Look*, 1910, Lenbachhaus, Munich.

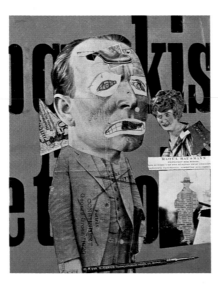

► Hermann Obrist,
Project for *Monument II*,
1898–1900.

► Vladimir Tatlin,
*Monument to the III
International*, 1919–
1920, Moderna Museet,
Stockholm. Tatlin
contributed monumental
works to several avant-
garde exhibitions
during this
period.

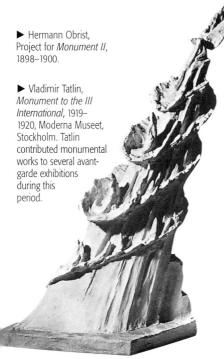

▼ Mario Sironi,
Venere del Porto, 1919,
Civico Museo d'Arte
Contemporanea, Milan.
In this disturbing urban
image, the subject has
lost every trace of
human identity and
only a suggestion of
femininity remains.

▼ George Grosz,
Untitled, 1920, Kunst-
sammlung Nordrhein-
Westfalen, Düsseldorf.
In another depersonalized
portrait, man has become
a maimed mannequin,
reduced to the level
of geometric volumes
and presented in a bleak,
anonymous context.

1915–1921

In Gray

This large canvas dates from 1919, and is now in the Pompidou Centre in Paris. Kandinsky declared that it "marks the end of my dramatic period" – in other words, his research into the reciprocal rapport between forms.

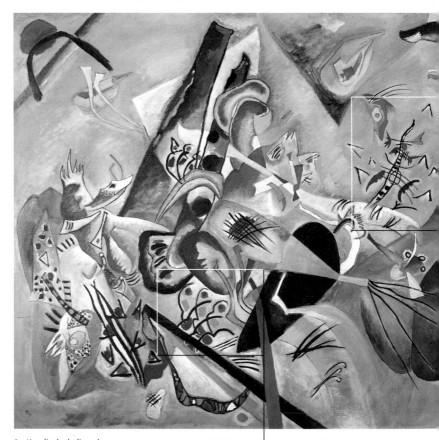

▶ Kandinsky believed that the abstract resided in the reciprocal relationship of forms evoked by "inner necessity". He felt that abstract art would be to the 20th century what 19th-century Realism had been to the academic tradition that preceded it.

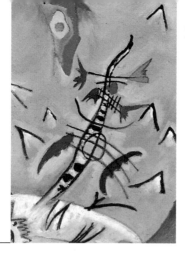

◄ The large rectangular format allowed Kandinsky to develop his language with an astonishing wealth of inventions. Here, small forms constructed with graphic characters acquire a self-contained configuration within the overall composition.

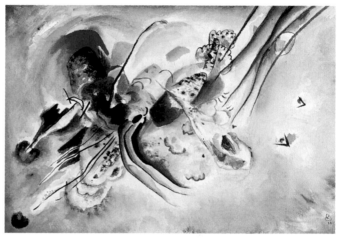

▲ Kandinsky, *Study for Painting with Two Red Spots*, 1916, Private Collection, Milan. This is one of the artist's works from the Moscow period, when his painting was limited by his state commitments. It is a very fine small watercolor, in which the energy of the colors moves gently in a diagonal direction.

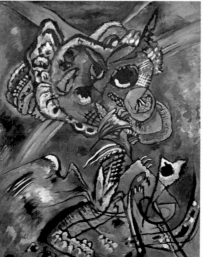

► Kandinsky, *Twilight*, 1917, Russian Museum, St. Petersburg. The theme of twilight had always fascinated the artist, who saw that part of the day as the most involving for the soul. Here, the tangle of colors evokes a feeling of emotional confusion.

Institutional opposition

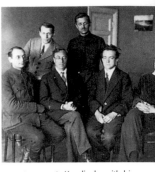

▲ Kandinsky with his Narkompros colleagues. Of Kandinsky's role in state affairs, Nina recalled: "Tatlin asked Kandinsky to bring his contribution to artistic renewal...Kandinsky accepted, emphasizing that he did not want to get involved in politics, and Tatlin promised him that his work would be exclusively artistic". Centre G. Pompidou, Paris.

Some 54 pictures were exhibited by Kandinsky at the XIX State Exhibition, held in 1920 in Moscow. It was a particularly important occasion for him: in the spring of that year, he was asked to found the Moscow Institute of Artistic Culture (Inchuk), for which he personally prepared the curriculum, and he also became president of the monumental art section. In his thinking about art at this time, he valued the concept of art as "synthetic totality", while also emphasizing the importance of the psychological effects of color. Thanks to this psychologistic aspect, he encountered the dissent of the majority of the members of the Institute, and it became difficult to share his theoretical framework with his colleagues. The programme set up by the Constructivists was preferred to his own; it concentrated on the material and mechanical aspects of art, with a view to developing design concepts for industrial production. Kandinsky's style was defined as emotive, and he himself was seen as "typically metaphysical and individualistic in the artistic field". In 1921, he was given the task of establishing contacts with other important teaching and avant-garde institutions; he left Moscow with his wife (acting as his secretary), and reached Berlin in December.

◀ Kandinsky, decorated tea cup and saucer, 1920–1921. The design of functional objects proved unsatisfying for Kandinsky.

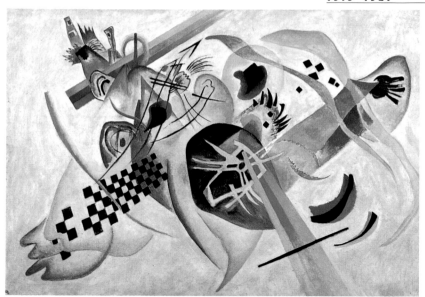

▲ Kandinsky, *On a White Background*, 1920, Russian Museum, St Petersburg. Here, each form has a significance in itself and each color explains its own function. The unifying element is the background color, which according to Kandinsky "strikes us as a great silence which seems absolute".

▼ Kandinsky, *Improvisation 11*, 1910, Russian Museum, St Petersburg. In this work, the style of which is markedly geometric, a yellow boat advances, rowed by a heroic figure. References to rowing boats – which represent the theme of Universal Judgment – occur frequently in Kandinsky's works from the Munich years, as do the themes of the apocalypse, resurrection, and rebirth.

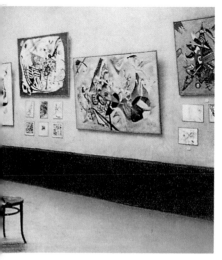

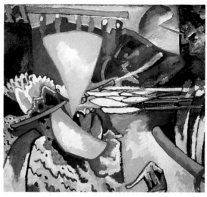

◀ Paintings by Kandinsky at the XIX State Exhibition in Moscow in 1920. Centre G. Pompidou, Paris.

The German role

▲ Erik Satie died in 1925. Experimental and eccentric, he was one of the foremost composers of the day.

Love and hate characterize relations between Russia and Germany during this period; history had bound them together with close political and cultural ties. Even in Germany, the political situation was very precarious. The forces of the left were strongly opposed by the conservative government, which increasingly reduced them to silence: proof of this was the shortlived Weimar Republic. However, creative vitality was by no means dampened and the contribution of the Germans to the development of Modernism and avant-garde movements was significant. This is amply demonstrated by the achievements of the Bauhaus, the school of architecture and applied arts founded in 1919 by the architect Walter Gropius. Unique of its kind and in its time, the Bauhaus set out to leave behind the old academic tradition in order to invent a modern method of training new artists. The hierarchy that had traditionally separated fine and applied arts was now totally dismantled. Meanwhile, in Italy, the proponents of Pittura Metafisica – Metaphysical painting – came to the fore, led by de Chirico, Carrà, Morandi, and De Pisis. Depicted in their works were men stripped of any identity, energy, or hope.

◀ Igor Stravinsky, the Russian composer, arrived in Paris in 1920. Already highly regarded for his innovative work, he followed in the footsteps of the anti-Romantic style of Satie. In his compositions he set out to eliminate previous musical culture.

▼ Boris Kustiodiev, *The Bolshevik*, 1920, State Tretyakov Gallery, Moscow. This revolutionary figure is very imposing, as solid as he is threatening. He is the creator of the new Russia.

▼ Before the Revolution, Russian children worked up to eight hours a day as soon as they reached 15.

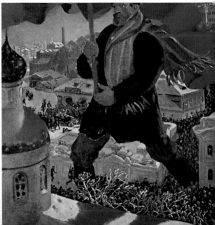

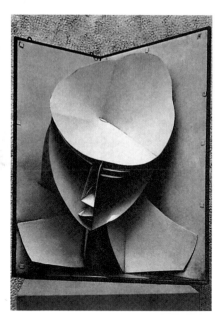

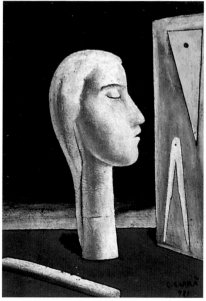

▲ Naum Gabo, *Woman's Head*, Museum of Modern Art, New York. Gabo was one of the most interesting representatives of the abstract currents that developed in Eastern Europe. His metal works were polished, pure geometrical forms. He was one of the men behind the *Manifesto of Realism* in Russia; in line with state politics, this movement was used by Stalin for propaganda purposes.

▲ Mario Sironi, *The Engineer's Lover*, 1921, Private Collection, Milan. The antithesis of Futurism, Metaphysical painting emerged in Italy between 1913 and 1922.

► Oskar Schlemmer, *Abstract Figure*, 1921, Bauhaus Archiv, Darmstadt.

▼ Michail Adamovich, Porcelain plate, State Porcelain Factory, Petrograd, 1921. In Russia, design and the applied arts were given a great boost during this period. Decoration generally celebrated the new state.

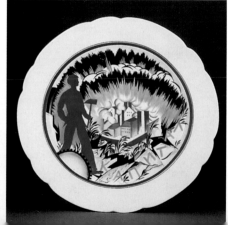

A change in teaching style

Young people who wanted to gain a place at Gropius' Bauhaus school were asked to devise personal graphic interpretations of figures. This example is by the German artist Oskar Schlemmer, also a key teacher at the Bauhaus.

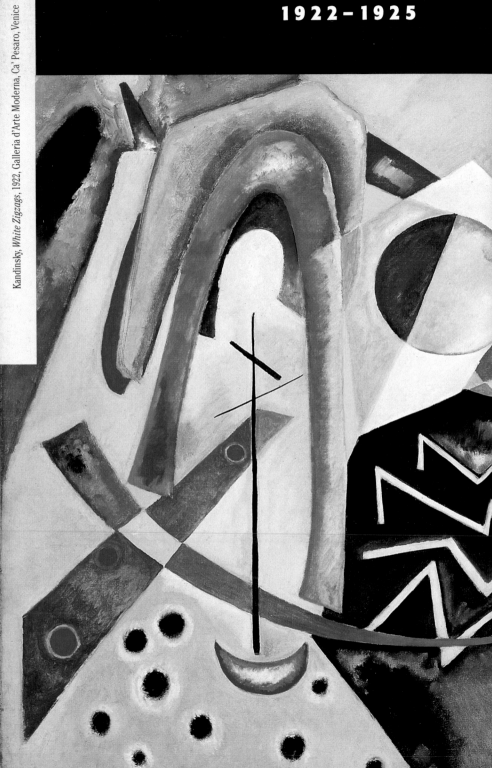

Kandinsky, *White Zigzags*, 1922, Galleria d'Arte Moderna, Ca' Pesaro, Venice

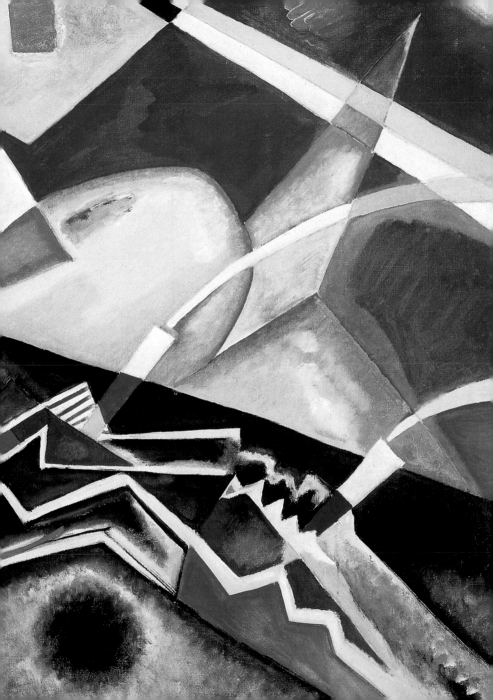

The adventure begins

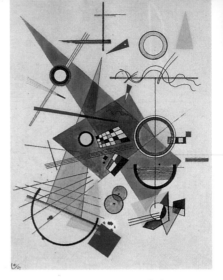

▲ Kandinsky, *Composition*, 1923, Civico Museo d'Arte Contemporanea, Milan.

Ⅰn Berlin, Kandinsky had few paintings with him and little money – works sold in Germany suffered the postwar devaluation of the German mark. The affection of Nina, a calm, intelligent companion, was a great support, but he missed the company of his artist friends, especially Marc, who had been killed at the front. He felt alone, in a professional sense as well, with the German capital dominated by Expressionism, New Objectivity, and Dada, all strongly critical of pure abstractionism. In March 1922, he met Walter Gropius, who had founded the Bauhaus in 1919 with the aim of giving life to "a new corporation of craftsmen" without class prejudice, and inventing "the construction of the future, which will be all one: architecture, sculpture, and painting". In June, Kandinsky arrived in Weimar, initially to teach theory of form, then painting in the workshop of mural painting. He was doubly content, because the principle of the psychology of form, first discussed in about 1890 by von Ehrenfeld and subsequently reclaimed by Gropius, had already formed part of his own studies (including his article *The Problem of Form* in the Blaue Reiter "Almanac"); secondly, he could resume part of the curriculum devised for Inchuk, which included a section on the theory of color, previously taken up by Goethe, and now expanded with his own theosophical reflections.

◀ Kandinsky, *St George 2*, 1911, Russian Museum, St Petersburg. The diagonal (the lance of the saint on horseback) was the object of lengthy study.

▼ Kandinsky, *Untitled*, 1923, Centre Pompidou, Paris.

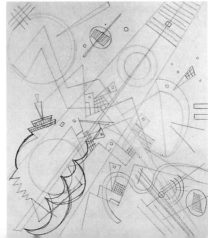

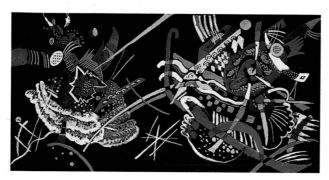

◀ Kandinsky, *Project for the Unjuried Exhibition*, 1922, Centre Pompidou, Paris. This is one of the studies for the mural paintings of an *Unjuried Exhibition*, on a rare black background.

Kandinsky and the triangle

In *On the Spritual in Art*, Kandinsky wrote: "The triangle moves slowly, almost imperceptibly, upwards, and where the summit is 'today', 'tomorrow' it will be the first section; in other words what is only comprehensible today at the summit, and for the rest of the triangle is still an obscure nonsense, will become tomorrow the life of the second section, dense with emotions and meanings. At the summit sometimes there is only a single man…".

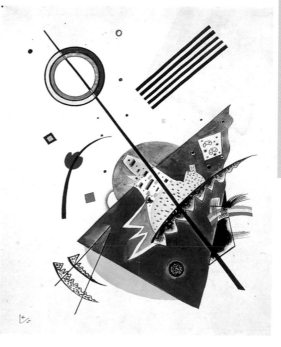

▶ Kandinsky, *Untitled*, 1922, Private Collection, Switzerland.

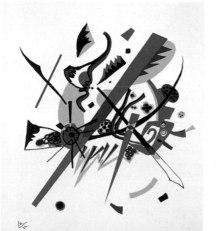

◀ Kandinsky, *Small Worlds I*, 1922, Centre Pompidou, Paris. The artist's portfolio of 12 woodcuts links his Munich years with reflections on the Moscow period and the imminent theoretical developments in his teaching at Weimar. The works depict small, perfectly balanced universes, with the color range limited mainly to yellow, red, and blue. Among the forms, the grid, the chessboard, and the wedge are included.

81

A decade of invention

I n Europe, the 1920s was a troubled and painful decade racked with political instability (destined to turn into international tragedy) and characterized by great social transformation and – in the world of art – important changes. The dominant classes and the wealthy bourgeoisie had a good decade, many enjoying lives of shameless luxury. While Kandinsky relinquished his Soviet citizenship in 1921 to embark on a new phase in his life in Germany, back in his beloved native Russia the political system born of the Bolshevik Revolution was establishing an ever-firmer grip. Industrial production was on the increase in the developed world, in particular in iron and steel, and key discoveries and inventions were made in various scientific fields – such as the discovery of vitamins. The invention of a method to synthesize fuel from the catalytic hydrogenation of carbon and the discovery of the anti-knocking properties of tetraethyl lead now made it possible to produce high-octane fuel.

▲ Fiat Eldridge Record "Mefistofele", 1923, Centro Storico Fiat, Turin. After the creation of the family saloon car and the Tourer came the racing car. The first great champions soon followed.

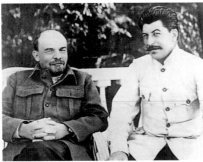

▲ Lenin and Stalin photographed in the countryside in 1922. The death of Lenin in 1924 led to the power struggle between Trotsky, Zinoviev, Kamenev, and Stalin. The last was to triumph.

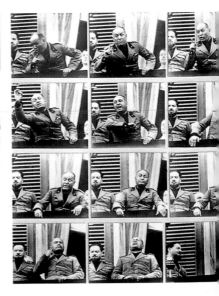

▶ Here, Mussolini exhorts his "marchers" from the balcony of Palazzo Venezia, Rome (1922). Fascism was quickly making its presence felt, developing from a movement into a party.

▼ Georgia O'Keefe in a photo by her husband Alfred Stieglitz (1922).

▲ Man Ray, *Rayograph*. The American artist introduced Dada to the United States, among other things inventing a form of "photography without a camera" by exposing film to strong light.

▼ Francis Picabia, *Music is like Painting*, 1913–1920, Sprovieri Collection, Rome. This French artist was successively involved in Fauvism, Orphism, Cubism, Dadaism, and Surrealism.

▼ Max Ernst, *Untitled* 1922, Thyssen-Borne-misza Collection, Madrid. The German artist Ernst, who was also a writer, was one of the most authoritative representatives of the Parisian Surrealist avant-

garde. He was part of the Dada movement in Cologne and came to Paris in 1922. He later invented the famous *frottage*, a rubbing technique that eliminated the conceptual participation of the artist.

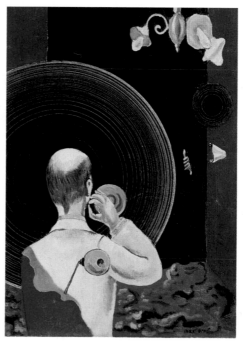

White Zigzags

This picture dates from 1922 and is now in the Galleria d'Arte Moderna at the Ca' Pesaro in Venice. One of Kandinsky's most complete works, the composition progresses diagonally, and a world of forms opens up before our eyes.

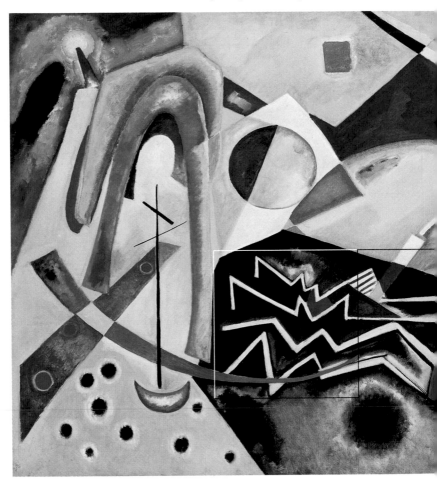

▶ Line as a geometrical value interested Kandinsky greatly. Besides the horizontal, vertical, and diagonal, he identified the free line, the curved line, and the broken line.

For the artist, line was a product of the point, arising from the "destruction of its extreme stillness" – both tension and direction at the same time.

▼ According to Kandinsky, in the figurative arts there was "an impressive richness of forms", which it was up to the artist to put on the canvas so that they could acquire meaning in the eyes of others. Abstract art was wrongly called "anarchic"; instead, it was necessary to cross the limited boundaries of appearance and believe in abstraction, which was "systematicity and order". The painter gives an interior life to every line, asking the viewer to liberate himself from traditional parameters and grasp the final dimension of existence that is within nature.

LIFE AND WORKS

A revolution in art education

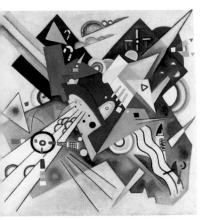

▲ Kandinsky, *Accentuated Angles*, 1923, Private Collection, Switzerland.

▼ The Blaue Vier pictured in the *Berliner Allgemeine Zeitung* (May 13, 1924). Their first exhibition (50 works) was held in New York in March 1925.

In a state of mind that was both serene and fuelled by explosive creative energy, Kandinsky created masterpieces like *Composition VIII* – shown at the August 1923 exhibition at the Bauhaus, and widely acclaimed – which rationalized and expanded on various ideas seen in the Munich *Improvisations*. The quality of his work for Gropius gained him a strong following: his idea for a questionnaire remains an educational stroke of genius – it asked teachers and students to look at the combining of forms (triangle, square, circle) and primary colors (yellow, red, blue). Further proof of the high esteem in which he was held was his first one-man exhibition, organized in New York by the Société Anonyme, of which he later became president. This was not only an important phase in Kandinsky's own life, but also in the broader context of 20th-century art: he was working with Paul Klee, Lyonel Feininger, Johannes Itten, Lothar Schreyer, Georg Muche, Oskar Schlemmer, and numerous young people who would shortly become worthy successors to their "masters" (this, and not "professor", was how Bauhaus teachers were addressed). It was with Klee, Feininger, and von Jawlensky that he founded the Blaue Vier, or Blue Four, an association directed by Emmy Scheyer with the aim of organizing international exhibitions, in particular in the United States. It was time to look across the Atlantic, to extend cultural and economic possibilities: witness the effect of the paintings of Claude Monet or the famous Armory Show in New York. The latter, the first international exhibition of avant-garde European art, constituted an earthquake for somnolent North American artistic taste.

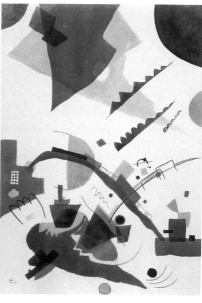

▲ Kandinsky, *Untitled*, 1940, Private Collection, Switzerland. As time passed, the artist increasingly rationalized forms, making them purer and less spontaneous.

▼ Kandinsky, *Heavy Among Light*, 1924, Private Collection, Switzerland. This work seems to arouse all the senses.

▲ Kandinsky, *Vibration*, 1924, Museum of Art, Philadelphia. This work is one of the most interesting from this phase. Kandinsky mixes his own stylistic elements with clipped, transparent forms borrowed from the painter Lyonel Feininger, and with compositional games taken from Paul Klee. However, he maintained his habit of using non-painterly terms for his titles.

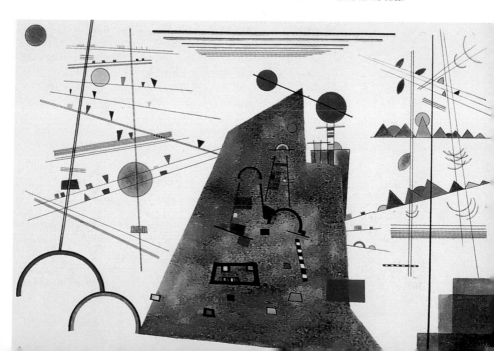

The art of the 1920s

I n the art world of the 1920s, Paris remained a desirable cultural capital. Instead of the Montmartre of the Cubists, there was the Montparnasse of the École de Paris and the Surrealists, while the aesthetic of unrestrained luxury triumphed in 1925 at the Exposition Internationale des Arts Décoratifs et Industriels Modernes, which gave its name to the Art Deco style. Meanwhile, Berlin was experiencing years of incredible creative tension amidst a climate of feverish political unease. Affluent New York was the most youthful capital, glowing with the lights of hotels, theaters, and shop windows. Since the early part of the century, life had been lived at an increased pace, with energy and creativity focused on the organization of the great exhibitions, both national and international: Paris in 1900, Turin in 1902, Milan in 1906, Brussels and Turin in 1911. The year 1920 marked the staging of three key events: the first international exhibition of Dada in Berlin; the last exhibition of the Futurists in Petrograd; and the first postwar Venice Biennale. In literature, celebrated works included the fourth volume of *À la recherche du temps perdu* by Marcel Proust, *Ulysses* by James Joyce, *Duino Elegies* by Rainer Maria Rilke, *Twenty Love Poems* by Pablo Neruda, *La Coscienza di Zeno* by Italo Svevo, and *The Great Gatsby* by F. Scott Fitzgerald.

▲ The funeral of Auguste Rodin took place in November 1917: on his tomb is a replica of *The Thinker*. In 1918, Gustav Klimt, Egon Schiele, Richard Wagner, and Claude Debussy also died.

◄ Miles Davis, born in 1926, became one of the most interesting figures in international jazz. By the 1920s, Afro-American music had arrived at a level of experimentation and fusion of diverse musical cultures, to the point where it could be defined an epoch-making phenomenon. Jazz also had links with cinema, a newly emerging form of artistic expression.

▼ Lyonel Feininger, *Marina*, 1924, Centre Pompidou, Paris. This American painter was one of the key figures of this period. Originally a Cubist, he later developed a style using fragmented forms. He was passionate about nautical themes.

▶ The composer Giacomo Puccini died in 1924. Other composers were coming to the fore, among them, the American George Gershwin, with unforgettable tunes like *Rhapsody in Blue*.

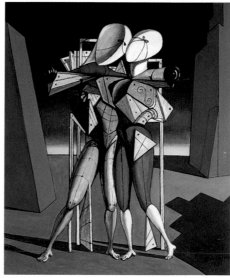

Neoplasticism

The Neoplastic avant-garde of the Dutch artist Theo van Doesburg, full of new proposals and polemic verve, was revealed in the pages of the magazine *De Stijl* from 1917. The movement was based on austere geometrical elements, interacting, mobile spaces, and primary colors.

▲ Giorgio de Chirico, *Hector and Andromache*, 1924, Galleria Nazionale d'Arte Moderna, Rome. In the 1920s, de Chirico's work revealed a more cultivated, elegant style, which influenced many of his contemporaries.

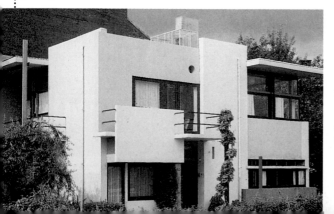

◀ Gerrit Rietveld, the Schröder House, Utrecht, 1923–1924. Here, movable interior walls made the living spaces very fluid.

Elementary Action

This celebrated work from 1924 is now housed in the Pompidou Centre in Paris. Huge, but luminous, the circle dominates the composition, its elevated position synonymous with spiritual elevation.

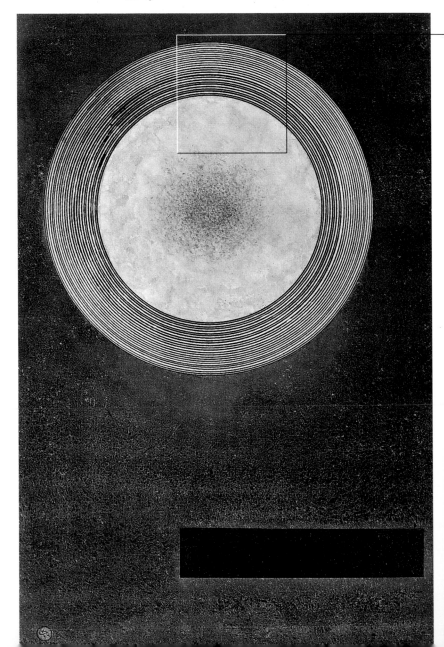

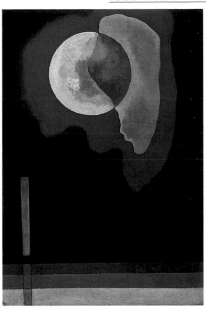

▲ During Kandinsky's years at the Bauhaus, circles became the most important motif in his work. Here, he uses several lines, not a single one, to create his circle, producing an almost mystical halo effect.

▲ Kandinsky, *Yellow Circle*, 1926, Private Collection, Switzerland. For Kandinsky, the circle replaced the horse and rider as his favourite subject: "I am so thoroughly and completely concerned with form – in my theories, too – because I want to penetrate its inner nature."

◀ Kandinsky, *Simple*, 1927, Private Collection, Basel. Here, the circle rises above the other forms, which are heavy and odious: it is the most modest of forms, but it asserts itself unconditionally. A triangle attempts to scratch the hardness of the square, but it is too small and the square does not give way.

One masterpiece after another

The Bauhaus school was strongly criticized by the conservative German regime, established there after World War I. In order to attack the new academy, the authorities attacked Kandinsky himself, who was pilloried in a frenzied article as being "in the service of the Communist regime". Kandinsky responded calmly, clarifying his political position and emphasizing that in his opinion any attempt to mix art and politics would be "one of the greatest enemies of art". Further complications led, however, to the closure of the Weimar school, which was invited to re-open on premises in Dessau, an industrial city in Saxony. The painter nonetheless maintained the concentration necessary to continue producing masterpieces of exceptional intensity. He created the Kandinsky-Gesellschaft company, an association of supporters and art collectors, who, in return for a remuneration to the artist, received works made expressly for them. He also continued to develop the theories contained in *On the Spiritual in Art*.

▼ Kandinsky, *Yellow, Red, Blue*, 1925, Centre Pompidou, Paris.

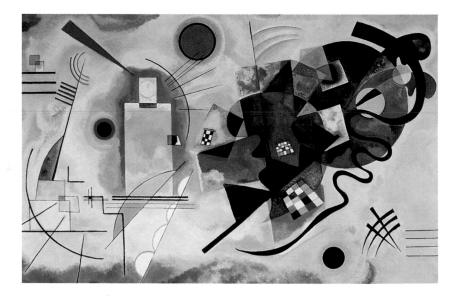

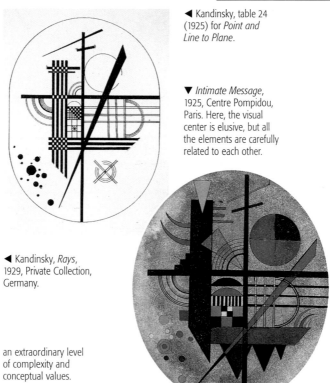

◄ Kandinsky, table 24 (1925) for *Point and Line to Plane*.

▼ *Intimate Message*, 1925, Centre Pompidou, Paris. Here, the visual center is elusive, but all the elements are carefully related to each other.

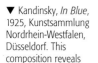

◄ Kandinsky, *Rays*, 1929, Private Collection, Germany.

▼ Kandinsky, *In Blue*, 1925, Kunstsammlung Nordrhein-Westfalen, Düsseldorf. This composition reveals

an extraordinary level of complexity and conceptual values.

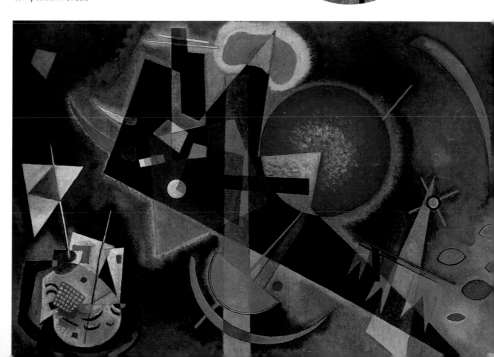

Innovations in design

T he early decades of the 20th century were fundamental in the development of modern design, which, along with photography and cinema, represented a new form of collective art. It had its origins in the 19th-century Arts and Crafts movement – the aims of which were encapsulated by William Morris in his call for an "art of the people, by the people, and for the people" – and developed in the context of post-Secessionist Art Nouveau. Design was finally elevated to art form status by the teachers and students of the Bauhaus school, where function was prioritized as highly as aesthetic considerations such as material and color in the design of everyday objects – standard types – that could be produced at reasonable cost. Meanwhile, in France, a related aesthetic was expressed in the form of Purism. This movement of "machine art" was founded by Amédée Ozenfant and Charles-Édouard Jeanneret (Le Corbusier), whose theories were expounded in the manifesto *Après le Cubisme* and in a review *L'esprit nouveau*, which ran from 1920 to 1925. Their aim was to return to the simplest and clearest of forms and styles – to "inoculate artists with the spirit of the age".

▲ The sensational Josephine Baker danced before Paris audiences in the mid-1920s.

▼ Felice Casorati, *Platonic Conversation*, 1925, Private Collection.

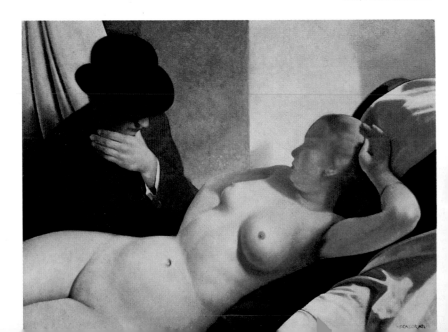

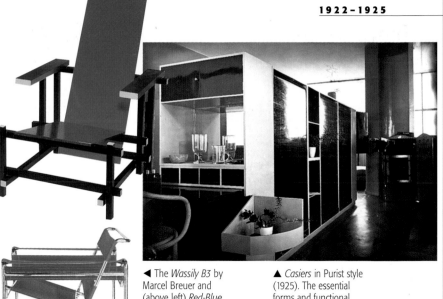

◀ The *Wassily B3* by Marcel Breuer and (above left) *Red-Blue Chair* by Gerrit Rietveld (1918) were classic pieces of modern design.

▲ *Casiers* in Purist style (1925). The essential forms and functional simplicity of Purism inspired the interior design of the period.

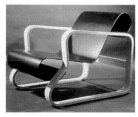

▼ Edward Hopper, *House by the Railway*, 1925, Museum of Modern Art, New York. The descriptive realism of Hopper's work exemplified the American Scene painting movement, which emerged after World War I. Concentrating on the observation of contemporary American society, the style was influenced by German New Objectivity.

▲ *Paimio chair*, by the Finn Alvar Aalto (1922). Aalto epitomized functional Northern European design.

◀ From 1932, Sidney Bechet was with Louis Armstrong and Duke Ellington among the best-loved jazzmen. The first jazz orchestras formed the soundtrack for the decade.

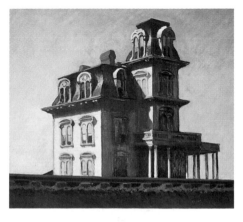

Kandinsky, *Accent in Pink*, detail, 1926, Centre Pompidou, Paris

The Bauhaus in Dessau

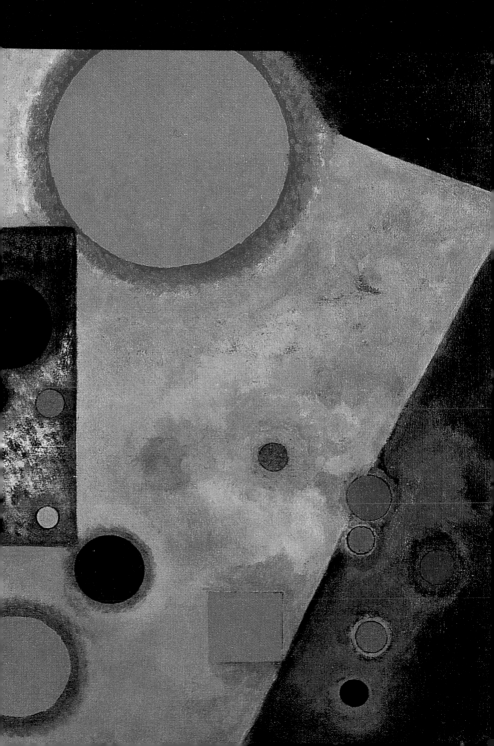

"Point and Line to Plane"

In the mid-1920s, the Bauhaus school moved from Weimar to Dessau. Building work on the school and the masters' accommodation was completed in the summer of 1925 and school work resumed in the autumn. In the meantime, Kandinsky persevered with his essay *Punkt und Linie zu Fläche* (known in English as *Point and Line to Plane*), published in 1926 in the *Bauhausbücher* series, edited by Gropius and Moholy-Nagy. Subtitled *A Contribution to the Analysis of Pictorial Elements*, it signalled another important stage in the artist's professional life and in the evolution of his artistic thought. It was very different from *On the Spiritual in Art*, which could be defined as a "mystical proclamation" and emphasized the significance of color rather than structure. With the lucidity of a mathematician and the passion of a child discovering the world around him, Kandinsky now gathered together his reflections from years of working and teaching in a sequence of observations on the relationship between fundamental geometrical elements and their relationship with the plane, with which they interact.

▲ Kandinsky, *Improvisation with Cold Forms*, 1914, State Tretyakov Gallery, Moscow. Kandinsky's style had evolved significantly since the vibrant masterpieces that had characterized his Munich period.

▲ The Bauhaus masters in 1926 are pictured grouped around Walter Gropius, who stands in the center. Kandinsky is fifth from the right. Centre G. Pompidou, Paris.

▶ Pictured here is Nina Andreevskaya, the painter's faithful companion. Photograph by Hugo Erfurth, Centre G. Pompidou, Paris.

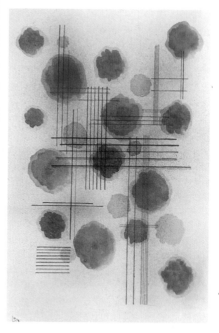

▼ Kandinsky, *Points in the Arch*, 1927, Private Collection, Paris. Here, geometric imagery and a disciplined composition exemplify the artist's work in the 1920s.

▶ Kandinsky, *Emotions*, 1928, Private Collection, Switzerland. In this work, spots of evanescent color seem to give voice to the spirit.

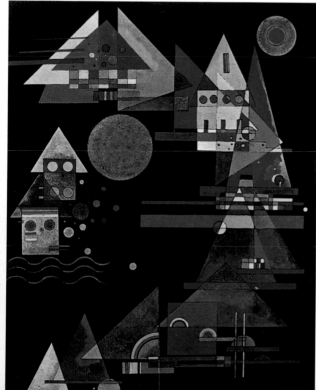

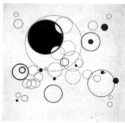

▲ Kandinsky, Early study for *Several Circles*, 1926, Centre Pompidou, Paris. The artist's years at Dessau were among the most creative and rewarding of his career.

99

The rise of fascism

While Kandinsky was launching himself into a productive new phase at the Bauhaus, both Italy and Germany were experiencing far-reaching political and cultural changes. In Italy, the Fascist party was advancing as a political force under the leadership of Benito Mussolini. After the march on Rome of 1922 and King Vittorio Emanuele III's request to form a new government, the Fascists obtained a majority in the elections of 1924. The dictatorship of Mussolini now emerged, shaping all aspects of Italian life and culture. Artistically, Novecento Italiano came to the fore and Mussolini was among the speakers at the group's first official meeting in Milan. Politically, Germany was still on its knees owing to postwar sanctions. The atmosphere was oppressive, and dominant movements in this decade were still linked to the strong polemical position of pre-war Expressionism. The radical Berlin Novembergruppe staged influential exhibitions during the early 1920s, while George Grosz and Otto Dix became the leading figures of the Neue Sachlichkeit (New Objectivity) movement. The term was coined by the director of the Mannheim Kunsthalle, Gustav Hartlaub, who spoke of "artists who have retained or regained their fidelity to positive, tangible reality."

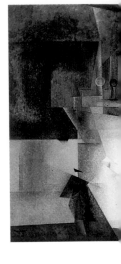

◀ Furniture in linoleum, 1933–1935, Triennale di Milano, Archivio Storico. The Milan Triennale was an important forum for international cultural debate.

◀ George Grosz, *Portrait of M Hermann-Neisse*, 1927, Museum of Modern Art, New York. In the paintings of George Grosz, the malaise of a nation in crisis can be seen. His figures are spectral and communicate feelings of moral squalor.

▶ Georgia O'Keefe, *Calla-lily, White and Black*, 1927, Georgia O'Keefe Museum, Santa Fe, New Mexico. O'Keefe was one of the most interesting artists in the United States at this time. She was born in Wisconsin, but it was when surrounded by the unrestrained nature of New Mexico that she could give free rein to her great sensual and spiritual charge.

▲ Lyonel Feininger, *Steam "Odin" II*, 1927, Museum of Modern Art, New York.

▼ Sealed watch for a handbag, Henry Blanc, c.1930, Geneva.

▶ Paul Klee, *Highway and Byways*, 1929, Wallraf-Richartz Museum, Cologne. This famous masterpiece was one of 8,000 works produced by Klee in his prolific career.

MASTERPIECES

Accent in Pink

Now in the Pompidou in Paris, this picture dates from 1926, the beginning of the Bauhaus Dessau period. In a conflict between angular and circular forms, a great square is invaded by circles. At the time, Kandinsky wrote: "Today I love the circle as I used to love the horse and perhaps more, because I find greater interior possibilities in the circle."

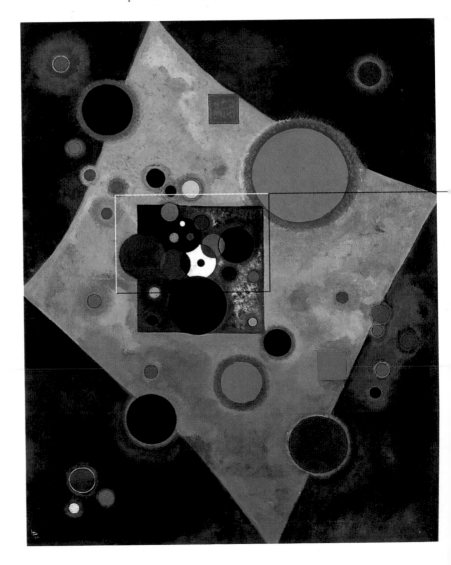

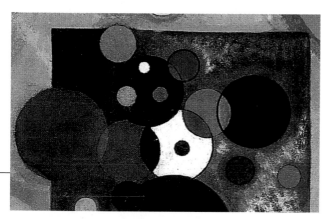

◄ Large or small, all of Kandinsky's circles are of equal importance, because a circle's force lies not in its dimension, but simply in its existence. The square is static and negative, while the circles express a positive force.

◄ Alexei von Jawlensky, *Abstract Head, Internal Vision, Pink Light*, 1926, Museum of Art, Philadelphia. The human face was an area of great fascination for Jawlensky, allowing him inexhaustible color study.

▼ Lyonel Feininger, *Broken Windows*, 1927, A. Moeller Fine Art, New York. Feininger loved transparent layers and clear-cut, well-modelled lines that were gentle to the eye.

▼ Paul Klee, *Image of Letters*, 1926, Centre Pompidou, Paris. Klee wrote: "algebraic and geometrical problems, mechanical problems represent equally educative moments on the road that leads to the essential: one learns to see behind the facade…to recognize what runs underneath…. The dark border rips and you enter another dimension."

1926-1932

Kandinsky
and Klee

▲ Kandinsky and Klee
dressed up as Schiller
and Goethe on the
beach at Hendaye
(1929). The close
friendship and mutual
respect between
Kandinsky and Klee
benefited their creativity
and productivity. Centre
G. Pompidou, Paris

During his time at the Dessau Bauhaus, Kandinsky became close friends with Paul Klee. The two lived with their families next door to each other in one of the Bauhaus masters' houses, designed in Cubist style by Walter Gropius (with furniture by Marcel Breuer) and intended to demonstrate "modern living". The two artists were spiritually in tune, Klee maintaining that "the dialogue with nature remains a *condicio sine qua non* for the artist". The year 1926 marked Kandinsky's 60th birthday and an appreciation of his work by Klee was published in a Dresden gallery exhibition catalogue. At the Bauhaus, both artists taught courses on pictorial form, as well as their own extra-curricular painting classes, and the 13-year age difference and increasing admiration of Kandinsky led Klee to describe himself – "in a certain sense" – as the older artist's pupil. As a teacher, Kandinsky was highly conscientious, spending hours in lesson preparation for a subject on which there were no existing textbooks. He wrote: "The problems of the science of art, which were initially imposed in a deliberately strictly limited environment, go beyond, in the course of their development, the limits of painting and in the end, the limits of art in general."

▼ Kandinsky, *Weighing*, 1928, Museum of Art, Long Beach. The Dessau years from 1925 to 1928 marked the height of the artist's circles period.

▶ Kandinsky, *Out of the Cool Depth*, 1928, Norton Simon Museum, Pasadena. In his sixties, Kandinsky was still full of energy and remained firm in his convictions.

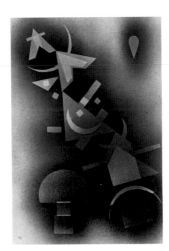

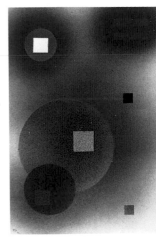

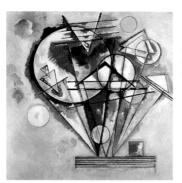

◄ Kandinsky, *On Points*, 1928, Centre Pompidou, Paris. Here, the visual force starts from the triangle and leaps towards the circle, source of spirituality.

◄ Paul Klee, *Steps and Ladders with Rungs*, 1928, Centre Pompidou, Paris.

► Kandinsky, *Untitled*, 1928, Private Collection, Switzerland. The staircase motif appears frequently in work fom this period.

▼ Lyonel Feininger, *Pacific Voyage III*, 1933, Norton Simon Museum, Pasadena. Feininger loved the sea – this delightful boat is imagined at sea, guided by large and powerful sails. The pale and luminous colors communicate a message of serenity, joy, and hope.

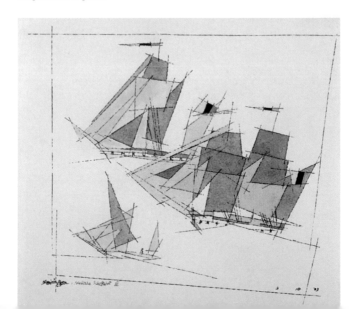

The new architecture

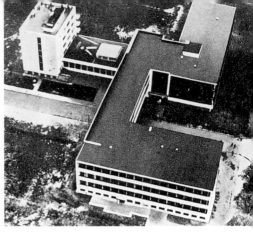

▲ Walter Gropius, The Bauhaus at Dessau, 1925. The entire complex – down to the last detail – was the joint project of teachers and students. The interior spaces were large and open.

Since remotest antiquity, man has been concerned with the creation of architecture. An art suspended between a practical obligation and pure artistic ideals, it enables a person to have a house, a place of work, and space for leisure or prayer. As had happened previously with Neoclassicism, architects now reacted to the rapid acceleration of social change and responded to the demands of a "new age of man". The developing taste was for function rather than style, simplicity rather than grandeur, a formal language of pure geometry rather than an abundance of decorative elements, reinforced concrete rather than finest marble: this was the beginning of the International Modern style (which developed as Rationalism in Italy). One of the key architectural events of the decade was the exhibition of Le Corbusier's Pavilion de l'Esprit Nouveau at the Exposition Internationale des Arts Décoratifs et Industriels Moderne in Paris in 1925. This Swiss-born architect, town planner, and writer was to become one of the most admired and influential figures in 20th century architecture.

▼ Le Corbusier, Chapel of Notre-Dame-du-Haut, Ronchamp, 1950–1955. The new, anticlassical style *par excellence* is demonstrated in this famous sail-like roof.

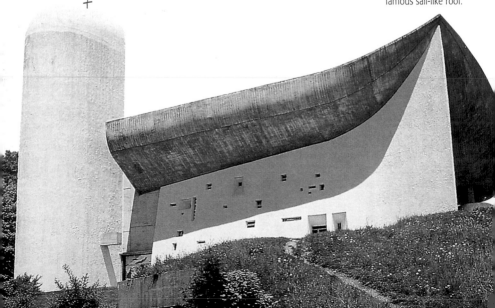

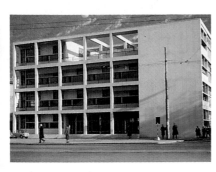

▲ Giuseppe Terragni,
Casa del Fascio, Como,
1932–1936.

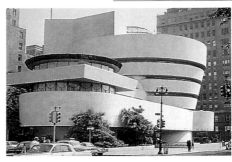

▲ Frank Lloyd Wright,
The Solomon R.
Guggenheim Museum,
New York, 1946–1959.

▼ The University
Library in Mexico City.
Modernity was also
making inroads in
Central and South
America. Numerous
public buildings went
up, their decorative
displays showing clear
links with tradition.

▲ Frank Lloyd Wright,
Falling Water, Bear Run
(USA), 1936. The
American's organic
architecture proposed
a union between nature
and construction for a
better human existence.

▶ The Chrysler
Building, in New York.
At 319 meters high,
during the year of
1930 this was the
highest skyscraper
in the world.

Changes at the Bauhaus

Just as Kandinsky's theoretical work was at its most intense, so was its practical application. However, the Bauhaus was not always the most receptive arena for his ideas: although they were shared by Klee – the two were almost alone in attaching value to the bringing together of art and nature within the school – numerous other artists at the school held theories quite different from his own. In 1925, Gropius handed over Kandinsky's workshop of mural painting to Hinnerk Sheper (his "Romanticism" in seeking a "total" work of art, was sometimes regarded as excessive), and the artist turned to other projects. One was a production at Dessau's famous Friedrich Theatre of Mussorgsky's *Pictures at an Exhibition*; Kandinsky described his role as depictor of the "forms that swam before my eyes on listening to the music." In 1928, Gropius left the Bauhaus to devote himself to his own architectural practice. His successor Hannes Meyer was soon replaced by architect Ludwig Mies van der Rohe, who introduced a new calm to the school. Kandinsky collaborated with him for the German Architecture Exhibition in Berlin in 1931, producing the ceramic decoration for the music room. The following year, amidst an increasingly repressive political climate, the Bauhaus moved again – to Berlin.

▲ Hans Arp, *Pagoda Fruit on a Bowl*, 1934, Private Collection, Paris. Arp, who participated in the first Surrealist exhibition in 1925, worked towards revolutionizing the concept of form.

◄ František Kupka, *Abstract in Black and White*, 1930, Centre Pompidou, Paris.

▼ Paul Klee, *Corridor*, 1930, Private Collection, Switzerland.

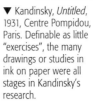

▼ Kandinsky, *Untitled*, 1931, Centre Pompidou, Paris. Definable as little "exercises", the many drawings or studies in ink on paper were all stages in Kandinsky's research.

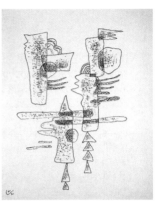

▲ Kandinsky, *Decisive Pink*, 1932, Solomon R. Guggenheim Museum, New York. The collector Guggenheim met Kandinsky in 1929.

Form and color

For Kandinsky, the possibilities of color and form were limitless; he wrote that color could be used in "an unlimited quantity of inexhaustible tonalities, each time to suit the aim of the image in question".

◄ Far left: Kandinsky, *Pale Tangle*, 1931, Private Collection, Switzerland. Here, the heavy forms stay at the base, as the lightweight soul takes flight.

◄ Kandinsky, *Untitled*, 1930, Centre Pompidou, Paris. This graceful small drawing was produced with ink on paper.

109

The dawn of Surrealism

▲ Ferrari and Valisi on the AR 2300 8c at Passo del Penice, Arese, Centro Documentazione Storica Alfa Romeo. The mysterious commodity of speed was now available to all.

At the end of the 1920s, the political situation in Europe was heating up. In Italy, Fascist ideology was increasingly taking hold and silencing the politico-intellectual forces that opposed it; in Germany, the National Socialist party was making strides, and in 1933 Adolf Hitler became Chancellor; and in Russia, Stalin was firmly established. Even the United States was experiencing a period of crisis. The fall of the New York Stock Exchange was a severe shock to the internal market and the entire international economic and financial system felt the effects deeply. Meanwhile, in art and literature, the first Surrealist manifesto – *Manifeste du surréalisme* – was published in Paris in 1924, the work of writer André Breton. Although the Surrealists shared an anti-classical, anti-rationalist artistic language with Dadaism (no absolute beauty, no formal rules), the latter's combative and brutal tones were replaced with a more positive spirit. The basic themes of Surrealism were investigation into the unconscious, the world of dreams, and the erotic impulse; Breton wrote of an aim "to resolve the previously contradictory conditions of dream and reality into an absolute reality, a super-reality." Among the sources of inspiration was the Metaphysical painter Giorgio de Chirico, who held a highly original view of art: "In order for a work of art to be immortal it has to emerge completely from human confines: good sense and logic will be the limits".

▶ Christian Schad, *The Operation*, 1929, Lenbachhaus, Munich. Initially a xylographer, Schad was part of the Swiss Dada movement, and was drawn to German New Objectivity in the 1920s.

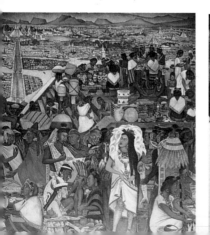

◀ Diego Rivera, *History of Mexico*, 1930–1932, Palacio Nacional, Mexico City.

◀ A child in Fascist uniform salutes il Duce (Rome, 1932).

◀ René Magritte, *The Human Condition*, 1933, National Gallery of Art, Washington, DC. The Belgian artist René Magritte was one of the key figures of Surrealism.

▼ Georgia O'Keefe, *Bleeding Heart*, 1932, Georgia O'Keefe Museum, Santa Fe, New Mexico.

▼ Pietro Melandri, *Mask of the Wind*, 1932, ceramic, Museo della Ceramica, Faenza.

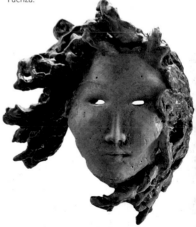

Suspended Force

This work, produced in 1928, is a small watercolor (34.5 x 47 cm/13½ x 18½ in) of exceptional importance. Kandinsky had always devoted much attention to watercolor technique, which gave him greater pictorial immediacy. The picture is now in a private collection in Milan.

◄ The diagonal, regarded by Kandinsky as a line of ascending motion, shows where the light circle is headed. The circle loses material consistency like the soul ascending towards the divine, cleansed of its earthly weight.

▼ In balance on the plane the remaining circles interact. There are three colors and three different weights: the circle is the development of the point, and therefore the expression of a primary force and may have thousands of different manifestations. In other works, Kandinsky establishes a relationship between the circle and musical notes; he held that the circle had acoustic-harmonic value.

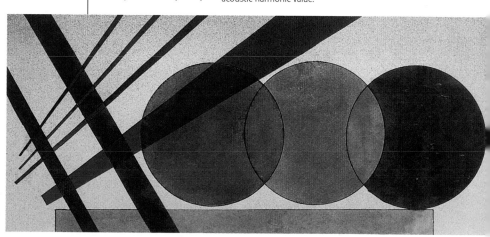

The Paris years

1933–1944

Arrival in Paris

The year 1933 was not a good one for Kandinsky. Klee had already departed for a teaching post in Düsseldorf and Mies van der Rohe, under pressure from the radical politicians of the right, was obliged to modify the theoretical framework of the Bauhaus, which resulted in general disheartenment. After victory at the elections in Saxony, the National Socialists moved to close the school. Mies van der Rohe managed to keep it going in the new Berlin location – a disused factory – but in April 1933, teachers and pupils were humiliated by a search by the Gestapo. On July 19, it was decided to dissolve the Bauhaus. Kandinsky stayed on until the end, before leaving Germany for good. Realizing almost immediately the danger he was in, he and Nina left for Paris, arriving in December 1933. A final productive period ensued for the artist, characterized by tremendous creative variety.

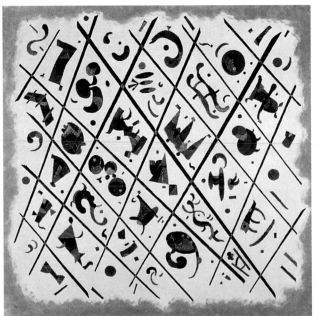

▲ Top: forms of amoeba, from *General Biology* by Barrows (1935). Precise links can be identified between these scientific tables and the painter's works.

◀ Kandinsky, *Division–Unity*, 1934, oil and sand on canvas, Museum of Modern Art, Tokyo. Kandinsky maintained that painting "can make use of an unlimited number of forms known as free". Here, the cross-hatchings do not create division; on the contrary they organize the energy.

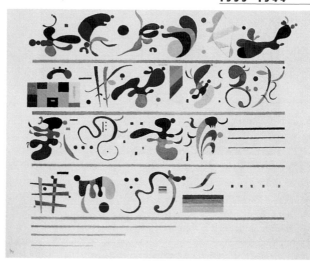

◀ Kandinsky, *Black Forms on White*, 1934, Fondation Zervos, Vézelay.

▲ Kandinsky, *Succession*, 1935, Phillips Collection, Washington. The increased geometricization of the artist's compositions became the leitmotif of the Paris years. In his exploration of the similarities between natural elements and pictorial forms, he remarked on "the experience of the small and great, the micro- and macrocosmic, coherence."

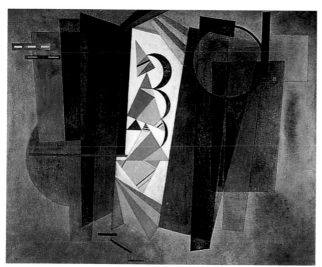

▲ Kandinsky, *Development in Brown*, 1933, Centre Pompidou, Paris. This was the last painting Kandinsky produced at the Bauhaus. A window of light seems to burst open behind the blinds: inside, life, the triangle, moves gracefully but energetically upwards.

▲ Kandinsky, *Submerged Blue*, 1934, Private Collection, Switzerland.

Developments in abstraction

The 1930s saw a considerable development in the language of abstraction. Kandinsky, Klee, and the Dutch painter Mondrian were the major points of reference for many contemporary and up-and-coming artists. The first international exhibition of abstract art was held in Paris in 1930, the same year that the Belgian Michel Seuphor and Uruguayan Joaquin Torres-García founded Cercle et Carré (Circle and Square). Its successor, František Kupka's Abstraction-Création, originated in Paris in 1931. The group attracted an enormous international following, including artists such as Max Bill and the American sculptor and painter Alexander Calder, whose trademark constructions were dubbed mobiles by Marcel Duchamp. An illustrated title, *Abstraction-Création: Art non-figuratif* was published annually. In Italy, important contributions were made by Alberto Magnelli and the northern Italians based in Como and Milan, such as Bruno Munari. Important forces for cohesion were the Galleria Il Milione and the critic Carlo Belli. Inspiration was still drawn from Expressionism, for example by the artists of the Roman School, formed in 1929 by Scipione, Mario Mafai, and his wife Antonietta Raphaël, who had worked in Paris with Soutine and Chagall. The influence of the group was to extend beyond the middle of the century.

▲ Bruno Munari, *Useless Machine*, 1934, Galleria Nazionale d'Arte Moderna, Rome. Munari used paper, colored wood, and cord to create this simple piece.

◄ The feminine taste of that era: actress Katherine Hepburn in masculine clothes and the Christian Dior "new look".

▲ John Cage, one of the great composers of the 20th century, is shown here in a photo from 1935.

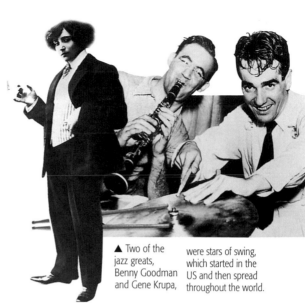

▶ The unconventional French writer Colette is pictured here in a typical pose. She rose to fame with her novel *Chéri*.

▲ Two of the jazz greats, Benny Goodman and Gene Krupa, were stars of swing, which started in the US and then spread throughout the world.

◀ Alexander Calder, *Colored Constellation*, 1943–1944, Private Collection, Paris. Calder was among the sculptors interested in producing "creative" abstraction; his fixed or mobile compositions were constructed of simplified forms in everyday materials such as wood and wire.

Sky Blue

This 1940 painting is in the Pompidou Centre in Paris. It is one of the most representative works from Kandinsky's Paris period. In the year of Nazi occupation, the painter returned to his favorite color, blue, because "the deeper you go, the more blue develops the element of calm".

▼ No symmetrical constraint governs this perfectly balanced composition, within which forms float in gentle suspension.

▼ The point of reference for this work is "biologized" nature; the result is a curious and amusing little creature, a one-off vital form.

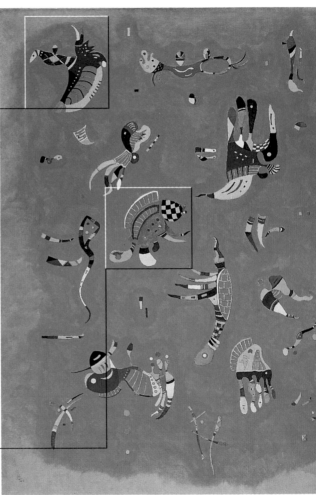

▶ Paul Klee, *Captive*, 1940, Beyeler Collection, Basel. The color blue also appealed immensely to Klee, communicating a sense of calm and serenity to him. Sadly, the artist was dying; he felt himself to be a prisoner of his illness (hence the title of the painting) and blue here conveys sadness and melancholy. The face looking out has one eye closed and one open, and an impassive mouth. Technically, the work is interesting: the base is a piece of jute cloth and the paint is enriched with glue. The imaginary black grating is made up of a web of broken lines, some forming rectangles. The chessboard was a recurrent element in the work of both Klee and Kandinsky, demonstrating their community of ideas and their collaborative spirit.

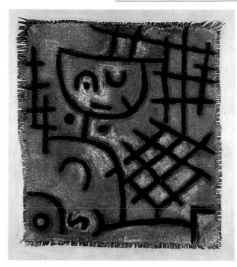

▼ Paul Klee, *Blue Flower*, 1939, Private Collection, Switzerland. Klee was a gentle and sensitive artist of extraordinary talent. This famous flower (a bizarre sunflower closed in on itself) is painted with watercolor on a piece of cotton prepared with oil and egg – an illustration of his great technical creativity.

1933–1944

New directions

In Paris, Kandinsky and Nina found an apartment at Neuilly-sur-Seine. The artist had a quiet social life and very little contact with the art world. The only other artists with whom he felt some affinity were Arp and Miró, both based in Paris from the 1910s, and Alberto Magnelli: they had in common the study of the origin of the essence of forms and the pictorial recreation of a kind of "organic absolute". A new phase in the artist's creativity began, with a move away from the geometrical towards more atmospheric compositions, often animated by biomorphic forms and playful or bizarre elements. There were some important technical innovations: the use of fine sand in the pigment and black tempera for background. Since the early 20th century, the painter had worked on the expressive possibilities of tempera, but he had never favored black, which he regarded as negative. Although this was a highly creative and productive phase in his career, Kandinsky found the artistic climate in Paris less than receptive to his brand of abstract art ("No one knows me in Paris," he wrote to a former pupil). The city was dominated by native figurative artists, and his own work was more appreciated by the Americans, the Swiss, and the Italians.

▲ Kandinsky, *Two Exceptions*, 1937, Maeght Collection, Paris. Here, the composition is structured in strongly subdivided zones.

▲ Kandinsky is pictured here in 1938, with customary intense expression. Photograph: Hannes Beckmann, Mnam-Cci, Centre G. Pompidou, Paris

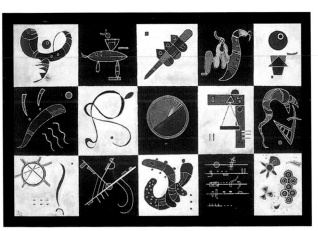

◀ Kandinsky, *Fifteen*, 1938, Kunstmuseum, Berne. Occasionally, the artist brought all his favorite motifs together in a single picture: the chessboard, white and black, the circle, the free line, the triangle, and the biomorphic form.

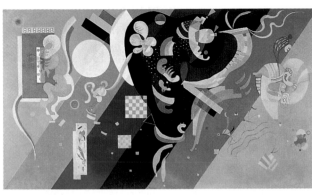

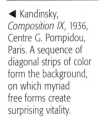

◄ Kandinsky, *Composition IX*, 1936, Centre G. Pompidou, Paris. A sequence of diagonal strips of color form the background, on which myriad free forms create surprising vitality.

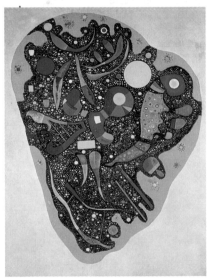

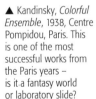

▲ Kandinsky, *Colorful Ensemble*, 1938, Centre Pompidou, Paris. This is one of the most successful works from the Paris years – is it a fantasy world or laboratory slide?

Little white spots emerge from the background like "balls" of energy.

▲ Kandinsky, *Green Figure*, 1936, Centre Pompidou, Paris. This work reveals the influence of the Surrealist artist Hans Arp, whom Kandinsky considered among the

most serious of the group. He would return to this type of "ectoplasmic" form in future works, such as *Complex-Simple*.

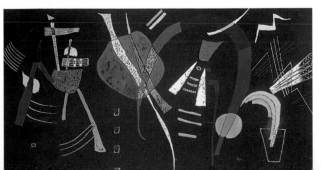

◄ Kandinsky, *Blue Arch*, 1938, Private Collection, Switzerland. The artist produced numerous works on a dark background during this period.

123

1933–1944

The malaise of an epoch

▲ Charlie Chaplin in *Modern Times* (1936). His comedy was very gentle, employing mild irony.

While Kandinsky's life – and his professional career – was drawing to a close, so too was the first half of the 20th century, a period that culminated in the tragedy of World War II. In terms of the arts, Realism and abstraction continued to coexist, even though the latter was opposed in some European countries, not least Germany, by the party forces in government. In 1937, having disposed of the Bauhaus – viewed as a symbol of a dangerous, critical independence – the Nazis now went about destroying dozens of abstract works in the country as a result of the notorious Munich exhibition, "Degenerate Art", assembled by the cultural experts of the regime. Much of the best work by avant-garde artists like Kirchner, Nolde, Dix, Marc, Grosz, Klee, and Kandinsky was destroyed or sold off. The decline in ethical and cultural values was in exponential acceleration. The invasion of Poland by German troops on Hitler's orders initiated World War II, the terrible climax to the precarious European political balance.

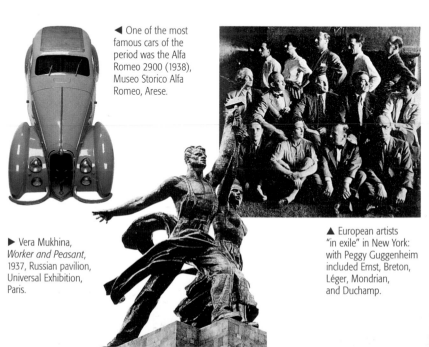

◀ One of the most famous cars of the period was the Alfa Romeo 2900 (1938), Museo Storico Alfa Romeo, Arese.

▶ Vera Mukhina, *Worker and Peasant*, 1937, Russian pavilion, Universal Exhibition, Paris.

▲ European artists "in exile" in New York: with Peggy Guggenheim included Ernst, Breton, Léger, Mondrian, and Duchamp.

Cinema, a developing art

Following the pioneering work of the Lumière brothers Auguste and Louis at the end of the 19th century (their Cinématographe was patented in 1895), cinema evolved very rapidly. The industry was revolutionized by the emergence of Technicolor in the 1930s.

▲ Clark Gable is pictured here reading the novel *Gone With the Wind*. He found lasting fame appearing in the 1939 film of the book, which tells the story of an love affair set against the background of the American Civil War.

▼ The interior of the Cariplo bank headquarters in Milan (1941).

◄ Alberto Savinio, *Self Portrait*, 1936, Civica Galleria d'Arte Moderna, Turin. Although little known, Savinio was one of the more interesting artists and intellectuals of the first half of the 20th century.

125

A quiet farewell

Kandinsky continued working into his seventies, and was appreciated by a small group of colleagues, critics, and gallery owners. The frivolity of Paris was very different from the revolutionary artistic atmosphere of the Munich of his day or the creative microcosm that had been the Bauhaus, and the artist felt he was an "out-of-fashion eccentric". He was not particularly keen on the Surrealists (apart from Arp and Miró), finding them rather vulgar and their work titilating and commercial. "The current public (that is the snobs) love spice," Kandinsky wrote to Jawlensky in March 1937. In the face of discouraging news – such as his having been categorized as a "degenerate" artist by the Nazis, who had sold most of his works held in German museums – he continued with methodical daily work and produced high-quality masterpieces. He also took part in two major international exhibitions (one in New York in 1936, the other in Paris in 1937). This final phase, judged controversially by the critics, was generally regarded as very complex. However, he remained true to the convictions he had outlined years earlier in *Point and Line to Plane*: "Permit me to say…that those who doubt the future of abstract art seem to base their opinion on a state of evolution comparable with that of amphibians, which are very far from higher vertebrates and do not represent the final result of creation but only the beginning". Kandinsky died from cerebrosclerosis on December 13, 1944, without suffering; perhaps, said Nina, for someone as superstitious as him, the number 13 was magical.

◀ After the artist's death, Nina wrote in her memoirs that the canvases on the wall were a "living memory" of her beloved husband.

▲ Top: Kandinsky, *Small Red Circle*, 1944; centre: *A Conglomerate*, 1934, Centre Pompidou, Paris; above: *Seven*, 1943, Private Collection, Paris.

► Kandinsky, *Links*, 1942, Private Collection, Switzerland. In this small oil work, some links are breaking, while others continue to exist, expressing the potential of vitality in a harmonious union. The vitality issues from the small central circle and spreads all around.

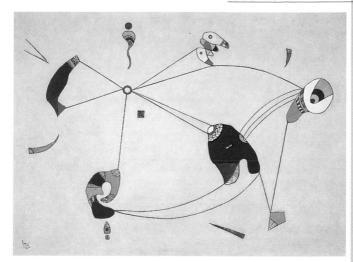

▼ Kandinsky, *Reciprocal Chord*, 1942, Centre Pompidou, Paris. Once again, the title has been borrowed from the language of music: for the painter, every tone of color corresponded to a sound, and all colors "listened to" with intensity reached the spirit through the eye. Music is a valuable aid in satisfying the spiritual needs of human beings.

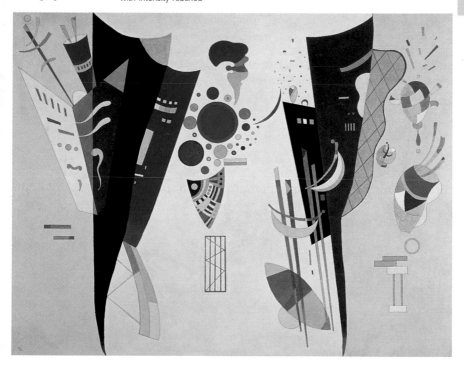

1933–1944

Bridges to
the future

▲ Gorni Kramer began his musical career in 1941: his orchestra helped to lighten those dark years for the Italians.

T he last years for Kandinsky were similar in essence to those of so many other European men: political, social, and economic breakdown became complete in every detail. War broke out, worked its destructive effects, and peace was quarrelled over. The nations involved in World War II were in a hurry to forget, but culture could not completely burn bridges with the past. Architecture in particular was at an important turning point: in the 1930s, the practice of urban planning evolved, focusing on large areas on the borders of industrial zones, its object to cater for the new needs of the working population, with thousands of cubic meters of construction for houses and places of work. Postwar reconstruction sparked off competition between the theorists to invent the new face of architecture. In 1936, Nikolaus Pevsner published *Pioneers of Modern Design. From William Morris to Walter Gropius*. Other architects began to take up the challenge; and like them, a new generation of painters, sculptors, musicians, and writers would build bridges to the future. Many of the artists from Kandinsky's day now chose to settle in New York. Among them was Piet Mondrian, once a member of the Abstraction-Création group, whose colorful American-influenced abstract style was epitomized by *Broadway Boogie-Woogie*.

▼ After World War II, hope for the future gradually revitalized the wartorn nations. In Italy, the Vespa was a symbol of a society in revival, (Completo d'Ascanio, Piaggio, 1946). As well as being a fine product of classic 20th-century design, it encapsulated the Italians' dreams.

◄ A child is carried by her rescuer during bombardments.

▲ Piet Mondrian, *Broadway Boogie-Woogie*, 1942–1943, Museum of Modern Art, New York. Extreme formal rigor characterized the work of this Dutch artist.

► Richard Hamilton, *Just what is it that makes today's homes so different, so appealing?*, 1956, Private Collection, UK. This photomontage is widely regarded as the first Pop art work.

▼ Arshile Gorky, *Garden in Sochi*, 1940, S Janis Gallery, New York. This American artist was one of many who overlapped different styles –

primarily Surrealism and Abstract Expressionism. Born in Turkish Armenia, he settled in New York in 1925.

Pop art

Pop art emerged in the UK in the 1950s and then developed in the United States, where it was sometimes referred to as Neo-Dada. The movement made use of the language of urban culture: advertising images, consumer products, comic books, and images from film and television.

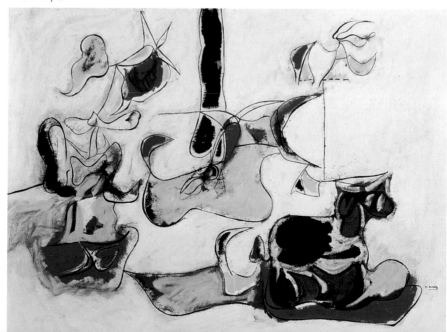

1933-1944

The last watercolor

This work was produced in 1944 using watercolor, ink and pencil on paper (it is now in the Pompidou in Paris). Despite his failing health, Kandinsky was active to the end and still highly capable of invention. During the Paris period, he painted more than 250 watercolors and gouaches.

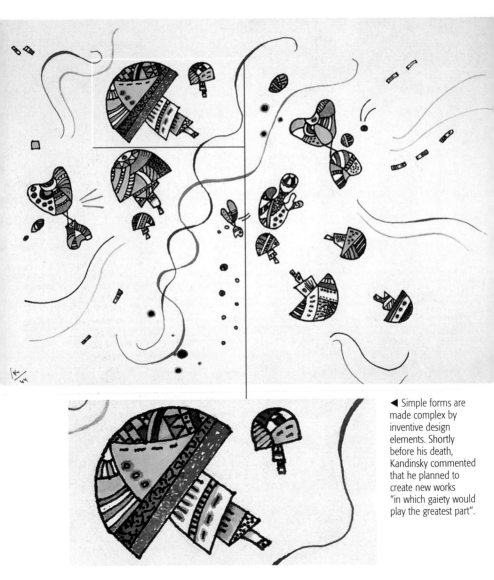

◄ Simple forms are made complex by inventive design elements. Shortly before his death, Kandinsky commented that he planned to create new works "in which gaiety would play the greatest part".

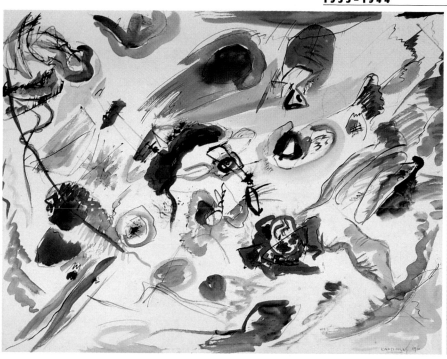

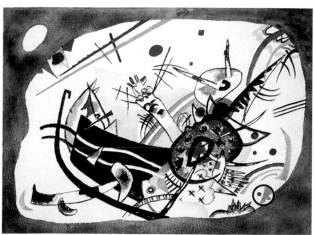

▲ Kandinsky, *Study for Green Border*, 1920, Centre Pompidou, Paris. In this watercolor, the border is ripped open to allow us to participate in the scene, in which a boat appears ploughing through a sea made choppy by moving forms.

▲ Kandinsky, *First Abstract Watercolor*, 1913, Centre G. Pompidou, Paris. Although it is difficult to give a precise date to this small painting, it is without doubt among the artist's finest. In the full creative brilliance of the Munich period, he produced a controlled composition, in which colors and forms launch their own vital messages to the observer. Naturalistic objectivity no longer had any value for him. He reinvented natural physiology, applying intuition to pictorial language, so that people could "perceive the spiritual in things".

131

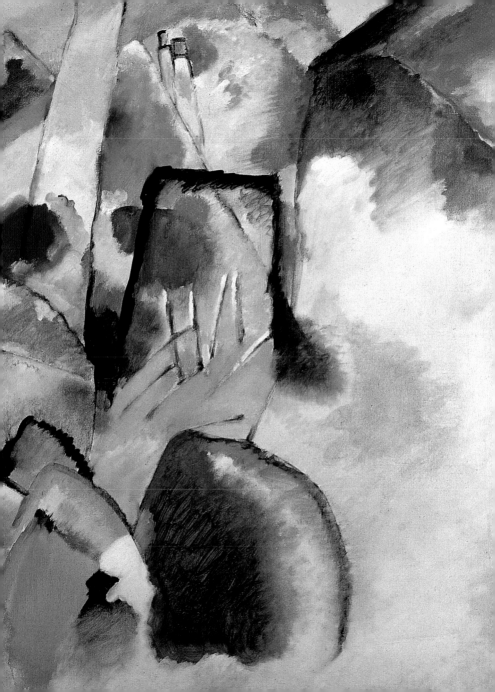

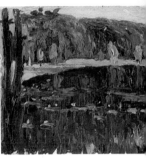

► Kandinsky, *Achtyrka – Dark Lake*, 1901, Lenbachhaus, Munich.

Note

The places listed in this section refer to the current location of Kandinsky's works. Where more than one work is housed in the same **place***, they are listed in chronological order.*

Basel, Kunstmuseum
The Arrow, p. 114.

Basel, Private Collection
Simple, p. 91.

Berlin, Staatliche Museen
Chocolats Extra, p. 17.

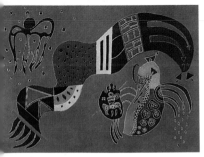

▲ Frank Lloyd Wright, Solomon R. Guggenheim Museum, New York.

▲ Kandinsky, *Moderated Impulse*, 1944, Centre G. Pompidou, Paris.

Berne, Kunstmuseum
Fifteen, p. 122.

Cologny-Geneva, Bibliotheca Bodmeriana
Pink Tangle, p. 69.

Düsseldorf, Kunstsammlung Nordrhein-Westfalen
In Blue, p. 93.

Germany, Private Collection
Rays, p. 93.

Long Beach, Museum of Art
Weighing, p. 104.

Madrid, Thyssen-Bornemisza Collection
Murnau – Houses on the Obermarkt, p. 37;
Untitled, p. 63;
Picture with Three Spots, p. 60.

Milan, Civico Museo d'Arte Contemporanea
Composition, p. 80.

Milan, Private Collection
Study for Painting with Two Red Spots, p. 73;
Suspended Force, p. 112.

Moscow, State Tretyakov Gallery
Odessa – The Harbor, p. 9;
Improvisation VII, p. 37;
Improvisation with Cold Forms, pp. 98–99;
Moscow – Smolensk Boulevard, p. 62;
Piazza Zubovsky in Moscow Seen from the Window, p. 69;

Munich, Städtische Galerie im Lenbachhaus
Young Woman in Russian Costume, p. 63;
Kochel – Waterfall I, p. 23;
The Comet (Night Rider), p. 23;
Twilight, p. 23;
Sketch for Achtyrka, p. 26;
In the Wood, p. 29;

Night, p. 29;
Colorful Life, p. 6;
Landscape with Rider on a Bridge, p. 37;
Yellow Horse, p. 45;
The Cow, p. 45;
Improvisation 18, p. 42;
Improvisation 19, p. 43;
Impression VI, p. 43;
Lady in Moscow, p. 43;
Design for the cover of *Der Blaue Reiter*, p. 44;
Paradise, p. 44;
Study of Color – Squares with Concentric Circles, p. 52;
Study for *Picture with a White Border*, p. 53;
Picture with a White Border, p. 53;
Horsemen of the Apocalypse II, p. 52.

Nagano, The Museum of Modern Art, Seibu Takanawa
Division-Unity, p. 116.

New York, Solomon R. Guggenheim Museum
The Blue Mountain, p. 37;
Crinolines, p. 36;
Improvisation 28 (2nd version), p. 43;
Decisive Pink, p. 109.

Paris, Private Collection
Morocco, p. 29;
Points in the Arch, p. 99.

Paris, Maeght Collection
Two Exceptions, p. 122.

Paris, Musée National d'Art Moderne, Centre Pompidou
Drawing of the Church of the Nativity in Moscow, p. 12;
The Old City II, p. 23;

▼ I M Pei, National Gallery of Art, Washington, DC.

Windmills, pp. 20–21, 32–33;
Old Russia (Russian Scene – Sunday), p. 29;
Landscape With Tower, p. 40;
Impression 5 – Park, p. 46;
Painting with a Black Arch, p. 34;
Picture with Red Spot, p. 58;
First Abstract Watercolor, p. 131;
Untitled, p. 63;
Birds, p. 62;
Painting on Light Ground, p. 66;
Achtyrka – Nina and Tatiana on the Veranda, p. 63;
Study for *Green Border*, p. 131;
In Gray, p. 72;
Project for the Unjuried Exhibition, p. 81;
Small Worlds I, p. 81;
Untitled, p. 80;
Elementary Action, p. 90;
Yellow, Red, Blue, p. 92;
Intimate Message, p. 93;
Early Study for *Several Circles*, p. 99;
Accent in Pink, p. 102;
On Points, p. 105;
Untitled, p. 109;
Untitled, p. 109;
Development in Brown, p. 117;
Conglomerate, p. 126;
Green Figure, p. 123;
Composition IX, p. 123;
Colorful Ensemble, p. 123;
Sky Blue, p. 120;
Small Red Circle, p. 126;
Reciprocal Chord, p. 127;
The Last Watercolor, p. 130.

Pasadena, Norton Simon Museum
Out of the Cool Depth, p. 104.

Philadelphia, Philadelphia Museum of Art
Vibration, p. 87.

Rotterdam, Museum Boymans van Beuningen
Lyrical, p. 42.

St Petersburg, Russian Museum
Improvisation 11, p. 75;
St George 2, p. 80;
Twilight, p. 73;
On a White Background, p. 75.

Switzerland, Private Collection
Accentuated Angles, p. 86;
Untitled, p. 87;
Heavy Among Light, p. 87;
Yellow Circle, p. 91;
Emotions, p. 99;
Untitled, p. 105;
Pale Tangle, p. 109;
Submerged Blue, p. 117;
Blue Arch, p. 123;
Untitled, p. 81;
Links, p. 127;
Seven, p. 126.

Venice, Galleria d'Arte Moderna, Ca' Pesaro
White Zigzags, p. 84.

Venice, Peggy Guggenheim Foundation
Landscape with Red Spots 2, p. 132.

Vézelay, Fondation Zervos
Black Forms on White, p. 117.

Washington, DC, National Gallery of Art
Improvisation 31 – Sea Battle, p. 53.

Washington, DC, The Phillips Collection
Succession, p. 117.

Wuppertal, van der Heydt Museum
Riegsee – Village Church, p. 36.

▲ Renzo Piano & Richard Rogers, Centre Georges Pompidou, Paris.

135

Note

All the names mentioned here are artists, intellectuals, politicians, and businessmen who had some connection with Kandinsky or his work, as well as painters, sculptors, and architects who were contemporaries or active in the same places as Kandinsky.

Andreevskaya, Nina, Kandinsky's second wife. A calm, steady companion, Nina accompanied him through his creative development. Her book *Kandinsky and I* recalls their life together. pp. 62–63; 68; 74; 98; 116; 126.

Apollinaire, Guillaume (Rome 1880 – Paris 1918), French poet and writer. Apollinaire's critical writing and editorial work provided crucial support to new avant-garde art movements by greatly increasing public awareness. His published work included *Cubist Painters* (1913) and a collection of poetry entitled *Calligrammes* (1918), p. 58.

Arp, Hans (Strasbourg 1887 – Basel 1966), German painter and sculptor. Linked with avant-garde movements, he took part in the famous Blaue Reiter exhibition of 1912. Kandinsky admired his work and the objects of his studies. One of the founders of the Dada movement, he worked with *De Stijl*, Cercle et Carré, and Abstraction- Création, pp. 108; 122; 126.

Azbé, Anton, art teacher to Kandinsky in the early days in Munich, p. 22.

Beethoven, Ludwig van (Bonn 1770 –Vienna 1827), German composer. He contributed in a significant way to the evolution of symphonic and chamber music. Among his most important works were 32 sonatas for the piano and nine symphonies, p. 42.

Bergson, Henri (Paris 1859–1941), French philosopher. The influence of Bergson on intellectuals at the turn of the century was significant. His conception of the temporal, founded on a qualitative and biological basis, is the foundation for Proust's *À la recherche du temps perdu*. His work includes *Matter and Memory* (1986) and *Creative Evolution* (1907), p. 38.

Bill, Max (Winterthur 1908 – Berlin 1994), Swiss architect, sculptor, painter, and designer. Pupil of Gropius at the Bauhaus, he was involved with planning and teaching, continuing the spirit of the school. He was part of the Abstraction-Création group and was the editor for the publication of the complete works of Le Corbusier, p. 118.

Breton, André (Tinchebray, Orne 1896 – Paris 1966), French writer. Founder, along with Aragon, Eluard, Picabia, and Ernst, of the Surrealist movement, for which he wrote the 1924 manifesto. The movement sought to give expression to the creativity of the subconscious, pp. 110; 124.

Breuer, Marcel (Pècs, Hungary 1902 – New York 1981), German designer and architect. Pupil and then teacher at the Bauhaus, he was responsible for some famous pieces of modern design. The "Wassily" B3 chair was made for Kandinsky's house at Dessau. With the rise of the Nazis he moved to New York and worked with Gropius on a number of important modern buildings. He designed the UNESCO building in Paris, p. 95.

Cézanne, Paul (Aix-en-Provence 1839–1906), French painter. The formal simplification of his figures and his experiments with the structural analysis of nature influenced the pictorial studies

◀ Hans Arp, *Portrait of Tzara*, 1916–1917, Musée des Arts, Geneva.

▶ Lyonel Feininger, *Clouds over the Sea I*, 1923, Feininger Collection.

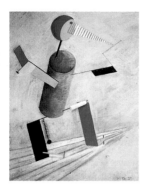

of many 20th-century artists: Picasso, Braque, Matisse, and Kandinsky saw in Cézanne a "prophet" of the art to come, p. 52.

Chagall, Marc (Vitebsk 1887 – Saint-Paul-de-Vence 1985), Russian painter. His work can be viewed as a celebration of the pictorial and folk traditions of the Russian people, pp. 49; 57.

Corinth, Lovis (Tapiau 1858 – Zandvoort, the Netherlands 1925), German painter. President of the Berlin Secession, Corinth took part in the shows put on by the Phalanx in Munich, p. 22.

Debussy, Claude-Achille (Saint-Germain-en-Laye 1862 – Paris 1918), French composer. His musical language brings together in a highly original way the French and Russian-Oriental traditions and the ideas of poetic

Symbolism. His masterpiece *Pelléas et Mélisande* (1902) provoked a scandal with its extremely innovative compositional and linguistic forms. A formidable pianist, he produced some of the greatest works for piano of the 20th century, pp. 14; 88.

Diaghilev, Sergei (Novgorod 1872 – Venice 1929), Russian theatre impresario and artistic director. He created the famous Ballets Russes in Paris, and some of the most important musicians and artists of the avant-garde collaborated with him, from Matisse to Picasso, and Stravinsky to Satie, pp. 28; 38.

Dix, Otto (Gera 1891 – Singen 1969), German painter. Founder of the Neue Sachlichkeit (New Objectivity) movement, he denounced in many of his paintings the horrors of World War I. Under the Nazi regime, his work, together with that of Kandinsky and other contemporary artists, was shown and then destroyed in the exhibition of "degenerate art", p. 124.

Ehrenfeld, Christian von (1859–1932), Austrian psychologist. Forerunner of the psychology of form (Gestalt), developed in Germany in about 1912. Gestalt promoted inquiry into human nature, without sacrificing the vision of the whole to the analysis of the individual part. This system of thought strongly influenced Kandinsky, p. 80.

Ernst, Max (Brühl 1891 – Paris 1976), German painter and sculptor. Involved in avant-garde movements such as Dada and Surrealism, Ernst also had contacts with the Blaue Reiter. With the advent of Nazism, he moved to the United States, pp. 83; 124.

Feininger, Lyonel (New York 1871–1956), American painter and graphic artist. He was part of the groups Die Brücke and Der Sturm. He was also linked to the Blaue Reiter group, and was especially friendly with Paul Klee. He taught at the Bauhaus and formed the group the Blaue Vier with Kandinsky, Klee, and Jawlensky, pp. 86–87; 89; 101; 103; 105.

Freud, Sigmund (Freiberg, Moravia 1856 – London 1939), Austrian psychiatrist. His work on the unconscious, the logic of dreams, and the sexual dimension of existence profoundly influenced 20th-century culture.

Goethe, Johann Wolfgang von (Frankfurt am Main 1749 – Weimar 1832), German thinker,

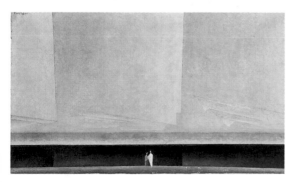

writer, and art theorist. In his famous work *Treatise on Color* (1810), he opposed Newton and professed a naturalism of classical derivation. His work had a strong influence on Kandinsky, p. 44.

Gropius, Walter (Berlin 1883 – Boston 1969), German architect. Founder of the Bauhaus (1919), he worked with the major artists of the 20th century for the development of liberal, functional, and socially useful art. His relationship with Kandinsky was not always easy, pp. 76–77; 80; 98; 100; 106.

Grosz, George (Berlin 1839–1959), German painter and designer. He saw his own work as an act of denunciation against the respectability and the militarism of pre-Nazi German society. Together with Otto Dix, he founded the New Objectivity group. His work was persecuted by Nazism as "degenerate art" and he was described as "Cultural Bolshevist Number One", pp. 71; 100; 124.

Hitler, Adolf (Braunau 1889 – Berlin 1945), German politician and statesman. Brutally influential on the cultural policy of Germany, preventing the development or formation of groups that were not aligned with the regime. The persecution of Jews forced many artists, including Kandinsky, to seek refuge in France, the UK, and the United States, pp. 110; 124.

Itten, Johannes (Südernlinden 1888 – Zurich 1967), Swiss painter. Teacher at the Bauhaus in the same workshop of mural painting as Kandinsky, he centered his pictorial studies on the psychology of color perception. After the closure of the Bauhaus, he moved on to the School and Museum of Applied Arts in Zurich. His published work included *Art and Color* (1967), p. 86.

Jawlensky, Alexei Gregorievich von (Torjok 1864 – Wiesbaden 1941), Russian painter. A friend of Kandinsky, he co-founded the New Association of Artists in Munich. His painting, influenced by Oriental mysticism and by the Russian-Byzantine icon tradition, drew stimulus from the work of Cézanne, Van Gogh, and Matisse. One of the founders of the Blaue Vier group, he was noted for his depiction of simplified heads, pp. 36; 41; 47; 86; 103; 126.

Kafka, Franz (Prague 1883 – Vienna 1924), German-speaking Jewish writer. Kafka combined in his work multiple sources of cultural origin: German, Jewish, and Slav. Among his major works are *Metamorphosis* (1917), *The Trial* (1925), and *Diary*, published posthumously in 1951, p. 13.

Kandinsky, Wassily Silvestro-vich, father of the artist, p. 8.

Kandinsky, Vsevolod, known as Volodya, son of the painter. His mother was the painter's second wife Nina. He died before he was three years old, p. 69.

Kirchner, Ernst Ludwig (Aschaffenburg 1880 – Davos 1938), German painter. A great exponent of German Expressionism, in 1905 he founded Die Brücke at Dresden. He took part in the second Blaue Reiter exhibition in Munich in 1912, pp. 55; 124.

Klee, Paul (Munchenbuchsee 1879 – Muralt 1940), Swiss painter. Along with Kandinsky, he was a pupil of Franz von Stuck. A friendship sprang up between the two, based on the sharing of pictorial ideals. In 1911, he joined the Blaue Reiter; in 1920, he began teaching at the Bauhaus; and in 1924, he co-founded the Blaue Vier together with

◀ Paul Klee, *Villa R.*, 1919, Kunstmuseum, Basel.

◀ Laszló Moholy-Nagy, dustjacket for the book *Bauhausbauten Dessau* (1930) by Gropius.

▼ Frantisek Kupka, *Piano Keys*, Národní Galerie, Prague.

Kandinsky, Feininger, and Jawlensky. His theoretical work was just as significant as his painting. His publications include *On Modern Art*, pp. 52; 59; 86; 101; 103; 104–105; 108; 116; 118; 121; 124.

Kubin, Alfred (Leitmeritz, Bohemia 1887 – Zwickledt, Austria 1959), Austrian painter, graphic artist and writer. A friend of Kandinsky and Klee, he was part of the Blaue Reiter, both as a theorist and as a painter. Preoccupied with death, he produced dark works with a disturbing psychological dimension, p. 22.

Kupka, František (Opoczno 1871 – Puteaux, Paris 1957), Czech painter. Kupka arrived at abstraction spurred by knowledge of the language of music. His work aimed at being the expression of the rhythm and dynamism of modern life and focused on such themes as the machine and jazz, p. 108.

Kustiodiev, Boris, Russian painter. His work concentrated on the celebration of Bolshevik Russia, the working class being his preferred theme, p. 76.

Lenin, Nicolai (Simbirsk 1870 – Gorky 1924), Russian politician and statesman. In 1912, he founded the Bolshevik party and the daily paper *Pravda*. He was the principal promoter of Soviet Communism. A Marxist, he wrote *What Is to be Done?* (1902) and *State and Revolution* (1917), in which he expounded his theories on the dictatorship of the proletariat. The first premier

of the Soviet Union, he died in 1923 without having been able to designate a successor, pp. 64; 82.

Macke, August (Meschede 1887 – Perthes-les-Hurles 1914), German painter. Among the promoters of the Munich group the Blaue Reiter, his work was the expression of a lyrical, luminous chromatic abstraction. His painting also drew creative stimuli from Futurism and Orphism. He was killed in World War I in 1914, pp. 44; 47.

Magnelli, Alberto (Florence 1888 – Meudon 1971), Italian painter. A self-taught painter, in 1913, inspired by Orphism, he moved on to abstraction. The work of Franz Marc was a profound influence, pp. 118; 122.

Malevich, Kasimir (Kiev 1878 – St Petersburg 1935), Russian painter. The founder of Suprematism, the expression of the "supremacy of pure sensibility in the figurative arts", he taught in various Russian cultural institutions: the Academies of Moscow and Vitebsk and the Institute for the Study of Artistic Culture (Inchuk). With Kandinsky, he opposed the idea that all art must be utilitarian. Clashing with Stalinist political culture, he was arrested in 1930, p. 65.

Marc, Franz (Munich 1880 – Verdun 1916), German painter. Marc was close to the Blaue Reiter group of Kandinsky and Macke, working on the preparation of the "Almanac" and the organization of the

exhibitions. The influence of Orphism and Futurism led him towards a luminous and dynamic abstraction. He was killed in World War I in 1916, pp. 29; 42; 44–45; 52; 80; 124.

Mies van der Rohe, Ludwig (Aachen 1886 – Chicago 1972), German architect. One of the most important architects of the 20th century, he was the director of the Bauhaus from 1930 to 1933, the year the school closed, pp. 108; 116.

Miró, Joan (Montroig 1893 – Palma de Majorca 1983), Spanish painter. The work of the great Surrealist was much admired by Kandinsky, pp. 122; 126.

Moholy-Nagy, Laszló (Bacsborsod 1895 – Chicago 1946), Hungarian painter. He introduced the principles of Neoplasticism and Constructivism to Bauhaus teaching. In 1928, he left the school along with Gropius in order to move to Berlin. Forced by Nazism to leave Germany, he moved to the United States, where he directed the new Chicago Bauhaus from 1937, p. 98.

▶ Georg Muche, *Picture with Grille at the Center*, 1919, Staatliche Museen zu Berlin, Nationalgalerie, Berlin.

Mondrian, Piet (Amersfoort, Utrecht 1872 – New York 1944), Dutch painter. Founder of Neoplasticism and the magazine *De Stijl*, together with Theo van Doesburg. His extremely rigorous pictorial approach was based on the exclusive use of rectangles and primary colors. He emigrated to the United States after the Nazi condemnation of "degenerate art", pp. 54; 118; 124; 129.

Monet, Claude, (Paris 1840 – Giverny 1926), French painter. Monet exerted a significant influence over Kandinsky's artistic development. In 1896, after seeing the *Haystacks* series, the Russian painter directed his own research towards the abolition of the object in art. It was an important stage in the move towards abstraction, pp. 16; 22; 33; 86.

Muche, Georg (Querfurt 1895 – Lindau 1987), German painter and

▲ Arnold Schoenberg, *The Red Look*, 1910, Lenbachhaus, Munich.

architect. From 1921 to 1927, he taught at the Bauhaus in Weimar in the weaving workshop. In 1927, he moved to Berlin to teach at Itten's school. Several of his paintings were shown at the Nazi show of "degenerate art", p. 86.

Münter, Gabriele (Berlin 1877–1962), German painter. A pupil of Kandinsky in Munich, she was his companion for 14 years, pp. 28; 62; 68.

Mussorgsky, Modest Petrovich (Karevo 1839 – St Petersburg 1881), Russian composer. He was the principal figure in the Group of Five, together with Balakirev, Borodin, Cui, and Rimsky-Korsakov. The piano suite *Pictures at an Exhibition* (1874), later adapted for orchestra by Ravel (1922), was set-designed by Kandinsky in 1928 for the Friedrich Theater in Dessau, pp. 14; 108.

Pevsner, Naum, known as Gabo (Briansk 1890 – Waterbury, Connecticut, 1977), Russian sculptor. Among the most significant figures in the Russian avant-garde, in 1920 he drew up the *Manifesto of Realism*, p. 77.

Puni, Ivan Albertovich (1894-1956), Russian painter, graphic artist, set designer and illustrator, p. 65.

Rembrandt van Rijn (Leiden 1606 – Amsterdam 1669), Dutch painter and etcher. His paintings were significant in the development of Kandinsky's abstraction. The discovery of the "temporal dimension" of painting

was made by Kandinsky after observing the works of Rembrandt, p. 17.

Romanov, Nicholas II (Carskoe Selo 1868 – Ekaterinburg 1918), Tsar of Russia. The last Tsar of Russia, he was forced to abdicate in February 1917 following the Bolshevik Revolution. In 1918, he was executed, along with his entire family by order of the revolutionary summit, pp. 11; 64.

Scheper, Hinnerk (Wulften 1897 – Berlin 1957). Student and teacher at the Bauhaus, p. 108.

Schiller, Johann Cristoph Friedrich (Marbach, Stuttgart 1759 – Weimar 1805), German poet, playwright, and philosopher. Inspirer of German Romanticism, he concentrated his thinking on strongly libertarian ethical and moral questions. With Herder and Goethe, he developed an aesthetic that recognized in Greek art the model of artistic perfection and the expression of true human essence, p. 44.

Schlemmer, Oskar (Stuttgart 1888 – Baden-Baden 1943), German painter, sculptor, stage designer, and writer. He taught at the Bauhaus from 1920 to 1929 in the sculpture and metalwork, later becoming head of the department of stage-design.

Nazism forced him to abandon teaching in 1933, pp. 77; 86.

Schoenberg, Arnold (Vienna 1874 – Los Angeles 1951), Austrian composer. Among the major representatives of German musical Expressionism, Schoenberg was also a painter. His works – mainly self-portraits – were often entitled *Visions*. From 1911, he began an intense exchange of letters with Kandinsky and took part in the activities of the Blaue Reiter, publishing the essay *Relationship with the Text* and participating in the group's first exhibition. His collaboration with Kandinsky developed around the theme of the "total work of art", of which *The Lucky Hand* is an expression, pp. 14; 38; 42; 70.

Lothar, Schreyer (Dresden 1886 – Hamburg 1966). A Bauhaus teacher in the theater workshop, p. 86

Semjakina, Anya, Kandinsky's cousin and his first wife, p. 16.

Stalin (Gori 1879 – Moscow 1953), Soviet politician. On the death of Lenin, he took charge of Soviet Russia as general secretary of the party, introducing a harsh policy of social and cultural repression known as the "Stalinist purges", pp. 82; 110.

Steiner, Rudolf (Kralyevica, Croatia 1861 – Dornach, Basel 1925), Austrian philosopher. Influenced by Goethe's "philosophy of nature", he took up theosophy and subsequently founded the Anthroposophical

Society (1913). His work included *The Philosophy of Liberty* (1894) and *Theosophy* (1904), pp. 36; 44.

Stuck, Franz von (Tettenweiss 1863 – Munich 1928), German painter and sculptor. Teacher to Kandinsky, Klee, and Jawlensky, he was involved in the Munich Secession (1892), pp. 15; 22.

Tatlin, Vladimir Evgrafovich (Harkov 1885 – Moscow 1953), Ukrainian painter, architect, designer, and theorist. Among the great figures in Constructivism, he held important institutional teaching roles. Director of the Department of Figurative Arts in Leningrad, where Kandinsky also worked, he viewed the work of his colleague with utter incomprehension, pp. 68; 71.

Ticheeva, Elisaveta, the artist's maternal aunt, she was an important influence during his childhood. Teacher and playmate, Elisaveta communicated a love of music to Wassily, p. 8.

Ticheeva, Lydia, the artist's mother, p. 8.

Vrubel, Mikhail (Omsk 1856 – St Petersburg 1911), Russian painter. One of the key figures in Russian Symbolism, p. 24.

Wagner, Richard Wilhelm (Leipzig 1813 – Venice 1883), German composer. Among the great reformers of modern music, he dedicated his life to the German musical theater and the creation of the "total work of art", a synthesis of poetry, music, and drama. His major works included *Tannhäuser*

(1843–1845), *Lohengrin* (1845–1848), *Tristan and Isolde* (1857–1859), and the trilogy *The Ring* (1853–1874). His most important written works were *Works of Art of the Future* (1849) and *Opera and Drama* (1850–1851), pp. 12; 14; 16; 44; 88.

Worringer, Wilhelm Robert (Aachen 1881 – Munich 1965), German critic and art historian. His most important text was *Abstraction and Empathy* of 1908. His ideas were developed by Kandinsky and the Blaue Reiter group, pp. 38; 44.

Zuloaga y Zabaleta, Ignacio (Eibar, Guipúzcoa 1870 – Madrid 1945), Spanish painter. Linked to the Symbolists, he took part in some of the Munich Phalanx exhibitions, p. 22.

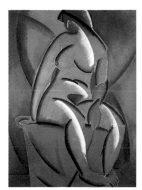

▲ Vladimir Tatlin, *Nude*, 1913, State Museum, St Petersburg.

1866 Born in Moscow to a well-to-do family; his father is a tea merchant and his mother an educated, cultured woman.

1869 Goes on a trip to Italy with his parents. His first memories of color impressions date from this period.

1871 The separation of his parents has a profound effect on the young child. An important figure is his aunt, who takes care of his education. In Moscow, visits to museums arouse strong emotions. Despite his young age, he has an excellent memory for colors. He receives formal education and also his first lessons in drawing and music.

▲ Kandinsky, *Church of the Nativity of the Virgin in Moscow*, 1886, Nina Kandinsky Legacy, Centre Pompidou, Paris.

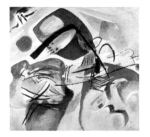

▶ Kandinsky, *Painting with a Black Arch*, 1912, Centre Pompidou, Paris.

His love for his native city and for Russian culture is profound. Among his first artistic efforts, a drawing of the Church of the Nativity stands out.

1886 He studies law and economics at the university of Moscow, specializing in political economics. Research work in the Russian province of Vologda brings him into contact with the colorful peasant culture, and he becomes fascinated by art. He visits the Universal Exhibition in Paris.

1892 He graduates, marries his cousin Anya, and goes on another trip to Paris. He takes on a law course at the university.

1895 At the Moscow Impressionist exhibition, one of Monet's *Haystacks* fascinates him because it demonstrates that painting can transcend objectivity. He becomes artistic director at the printing works Kušverev.

1895 He is offered a position as lecturer at the University of Estonia but declines it. He decides to move to Munich, where he starts to study art seriously. He is drawn to the Secessions.

1897 He enrols at the school of the famous artist Anton Azbé. Here, he meets the first friends of the Munich years: Gabriele Münter (his companion for the next 14 years) and Alexei von Jawlensky.

1900 He studies at the Munich Academy of Art with Franz von Stuck. He founds the Phalanx, the association of avant-garde artists who promote innovative theoretical principles (the following year, he becomes president). His pencil studies on the theme of knights date from this period.

1902 He is involved with the Berlin Secession, and exhibits his paintings. He works on poetry and philosophical theories, as well as considering theatrical works and the links between painting, color, and set design. He paints the picture *Old City II*.

1904–1907 A number of exhibitions are staged in various European cities. He travels in Germany (meeting members of Die Brücke) and Italy.

1908 He moves to Murnau, a mountain resort where he founds the Neue Künstlervereinigung (the New Association of Artists)

◀ Kandinsky, *Old City II*, 1902, Centre Pompidou, Paris.

and paints his first *Improvisations*. He writes *The Yellow Sound*.

1910 He intensifies his version of abstraction, especially within the Blaue Reiter (Blue Rider) group, founded with Franz Marc.

1911 Publishes *On the Spiritual in Art* and the *Blaue Reiter Almanac*.

1913 Publishes *Reminiscences*. Takes part in the Armory Show in New York.

1915 He returns to Russia, and ceases painting for a while.

1916–1918 He passionately dedicates himself to his theoretical work while working at the art institutions created after the Revolution; he is a member of the Department of Fine Arts at the People's

Commissariat. On February 11, 1917, he marries his second wife, Nina.

1919–1920 He is a member of the editorial committee for the Encyclopedia of Fine Arts and is involved in the founding of the Institute of Revolutionary Artistic Culture. He holds an official exhibition in Moscow.

1921 He decides to leave Russia to teach at the Bauhaus school in Weimar, founded by Walter Gropius, first in the workshop of mural painting and later in the free painting workshop. He also works on school publications.

1924 With Klee, Feininger, and Jawlensky, he founds Die Blaue Vier (Four Blues) group. Many masterpieces are produced in this phase, among them *Elementary Action*. He rises in critical and public esteem.

1925 He stays at the Bauhaus after the move to Dessau and keeps up his teaching and painting.

1926 Publishes *Point and Line to Plane*, a short treatise dealing with his theory of painting.

1927 Holds numerous exhibitions in Germany and abroad (at the Cercle et Carré in Paris, the Galleria Il Milione in Milan, in Switzerland and in Austria).

1928 Becomes a German citizen.

1929 First one-man show, Paris.

1931 With architect Mies van der Rohe, director of the Bauhaus, he creates a music room at the Universal Exhibition in Berlin.

1933 After the Bauhaus closes, he decides to move to Paris.

1934 From now on, his paintings carry French titles. A long period of intense creativity follows.

1939–1943 Takes French nationality. He spends the war years in his home in Paris continuing to work.

1944 His last work is *Tempered Impulse*. He dies on 13 December of cerebrosclerosis at the age of 78.

▼ Kandinsky, *Composition IX*, 1936, Centre G. Pompidou, Paris.

▶ Kandinsky, *Elementary Action*, 1924, Centre Pompidou, Paris.

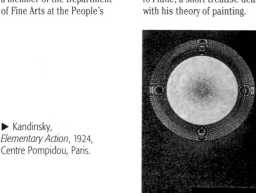

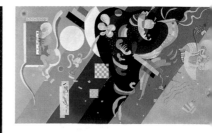

A DK PUBLISHING BOOK

www.dk.com

TRANSLATOR
Fiona Wild

DESIGN ASSISTANCE
Rowena Alsey

EDITORS
Louise Candlish, Jo Marceau

MANAGING EDITOR
Anna Kruger

Series of monographs
edited by Stefano Peccatori and Stefano Zuffi

Text by Paola Rapelli

PICTURE SOURCES
Archivio Electa; Basel Kunstmuseum; Musée National d'Art Moderne,
Centre Georges Pompidou; Städtische Galerie im Lenbachhaus

Elemond Editori Associati wishes to thank all those museums and
photographic libraries who have kindly supplied pictures, and would be pleased
to hear from copyright holders in the event of uncredited picture sources.

Project created in conjunction with
La Biblioteca editrice s.r.l., Milan

First published in the United States in 1999 by DK Publishing Inc.
95 Madison Avenue, New York, New York 10016

Kandinsky, Wassily, 1866–1944.
 Kandinsky. -- 1st American ed.
 p. cm. -- (ArtBook)
 Includes index.
 ISBN 0-7894-4852-1 (alk. paper)
 1. Kandinsky, Wassily, 1866–1944 Catalogs. I. Title.
 II. Series: ArtBook (Dorling Kindersley Limited)
 N6999.K33A4 1999
 760'.092--dc21 99-32115
 [B] CIP

First published in Great Britain in 1999
by Dorling Kindersley Limited,
9 Henrietta Street, London WC2E 8PS

A CIP catalogue record of this book is available from the British Library.

ISBN 0-7513-0778-5

2 4 6 8 10 9 7 5 3 1

Printed by Elemond s.p.a. at Martellago (Venice)